Northwest Coast Indian Graphics

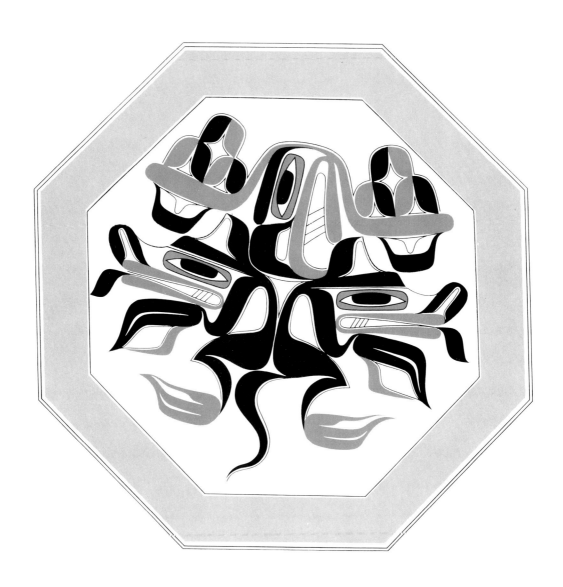

A TRIBUTE TO MY GRANDMOTHER / Art Thompson, *1981, edition 160,*
49.5 x 53.5 cm; sienna, light green, and black on white

Each side of the octagon represents one of the eight stages in the life of the artist's late
grandmother. The two wolves, within the octagon, were owned by her and are portrayed
leaving the cycle of life. The thunderbird, at the top of the octagon, represents the artist,
still within life's cycle. The design was taken from an original painting on a drum.

Northwest Coast Indian Graphics

An Introduction to Silk Screen Prints

Edwin S. Hall, Jr.

Margaret B. Blackman

Vincent Rickard

University of Washington Press Seattle & London

All photographs are by Vincent Rickard, with the exception of the following: The Public Archives of Canada (George M. Dawson): 28; the British Columbia Provincial Museum: 32, 40, 48; Margaret B. Blackman, 44, 134, 136, 137; Jim Dusen: 53, 103, 104, 119, 123, 124.

Library of Congress Cataloging in Publication Data

Hall, Edwin S., 1939-
 Northwest Coast Indian graphics.

 Bibliography: p.
 1. Indians of North America—Northwest coast of
North America—Art. 2. Serigraphy. I. Blackman,
Margaret B. II. Rickard, Vincent. III. Title.
E78.N78H27 760'.8997'09795 81-3397
ISBN 0-295 05835 9 AACR2

Printing by United Graphics Inc., Seattle, Washington
Bound by John H. Dekker & Sons Inc., Grand Rapids, Michigan

Acknowledgments

The writing of this book would, of course, never have occurred without the renaissance in contemporary Northwest Coast Indian art. We are indebted to the many artists who are among those responsible for this revival and whose works are reproduced in this book: Patrick Amos, Doug Cranmer, Joe David, Reg Davidson, Robert Davidson, Beau Dick, Freda Diesing, Roy Hanuse, Walter Harris, Mark Henderson, Barry Herem, Calvin Hunt, Henry Hunt, Richard Hunt, Tony Hunt, Hupquatchew, Floyd Joseph, John Livingston, Ken Mowatt, Duane Pasco, Tim Paul, Glen Rabena, Bill Reid, Jerry Smith, Vernon Stephens, Art Sterritt, Norman Tait, Art Thompson, Roy Vickers, Clarence Wells, Francis Williams, and Donald Yeomans. Several of these artists have discussed their work with us at some length, and we thank them for taking the time to share their knowledge of Northwest Coast art with us. Thanks are also due to Canadian Impressions, Canadian Native Prints Ltd., and The Legacy for allowing us to reproduce prints they have published.

We would also like to acknowledge the efforts of the following individuals and institutions: Debora Lang, for typing the manuscript; Norm Frisch, for map-making; Ailsa Crawford, Barbara Hall, Bill Holm, and Lisa Mitchell, for reading and commenting on the manuscript; The British Columbia Provincial Museum in Victoria, for supplying all the historical photographs; Doreen Jensen, Leona Lattimer, Mardonna-Austin McKillop, Bud Mintz, Phil Nuytten, and Dave Young for providing historical data; Dale Rickard, for suggestions on printing layout; and the National Museum of Man, Ottawa, for partial funding of the research upon which this publication is based; Richard Inglis for providing several prints for photographing; George MacDonald and Richard Inglis for sharing their knowledge of Northwest Coast Indian graphics.

The silk screen designs included in this book were selected to show a range of individual styles, regional styles, and subject matter. Some were also chosen to illustrate particular points made by the authors. Inclusion of specific designs is not intended as comment on artistic or technical quality.

Caption titles are those given by the artist, while titles in parentheses are descriptive ones given by the authors when the artist had not titled the print. Parentheses are similarly used in designating the year of the print. The edition size excludes artist's proofs and all other special copies. All measurements are given in centimeters and refer to paper size; unless otherwise specified, height precedes width. Some of the designs shown were printed on two or more different colors of paper; only the paper color of the particular print seen by the authors is noted in the caption.

15 January 1981

Contents

Prints

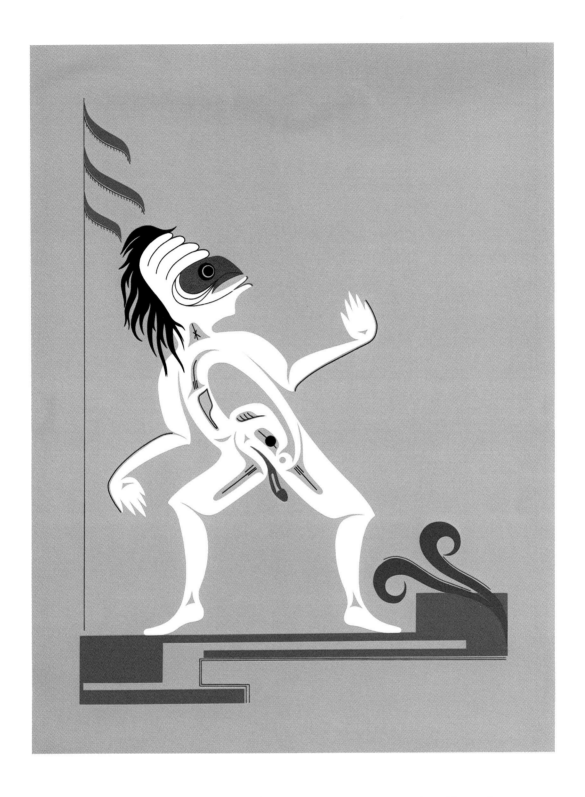

POOK-UBS / Art Thompson, *1980, edition 125, 46 x 61 cm; green, white, blue, red, and black on gray (coated over white)*

Pook-Ubs is the spirit of a drowned whale hunter. He was represented in Westcoast winter dances by a masked dancer with a white-painted body.

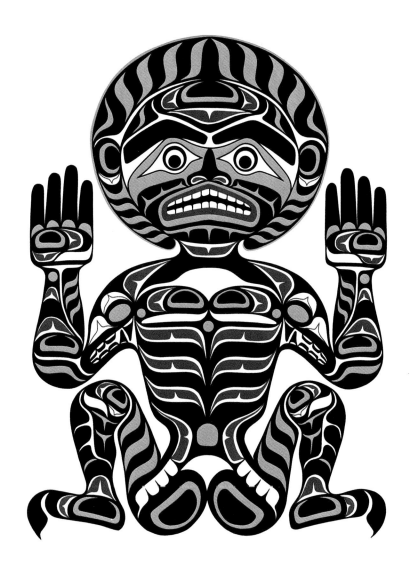

KWA-GULTH MOON / Richard Hunt, *1978, edition 125, 65 x 49 cm;*
black, yellow, and red on white

Rows of U-shapes, and/or S-shapes, rounded ovoid forms, and the use of yellow as a
design color identify this figure by Richard Hunt as Kwakiutl.

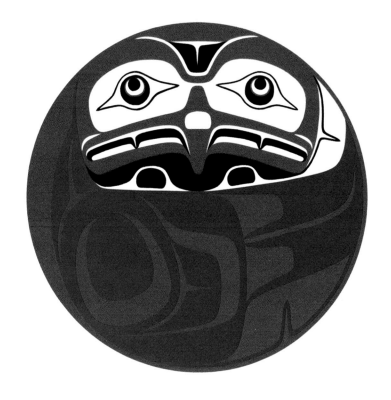

EAGLE DANCER / Donald Yeomans, *1980, edition 225, 33.0 x 27.9 cm;*
red, blue, and black on white

A dance performed by Haida artist Reg Davidson at a celebration held in the Haida vil-
lage of Masset in March, 1980 was the inspiration for Yeomans' print.

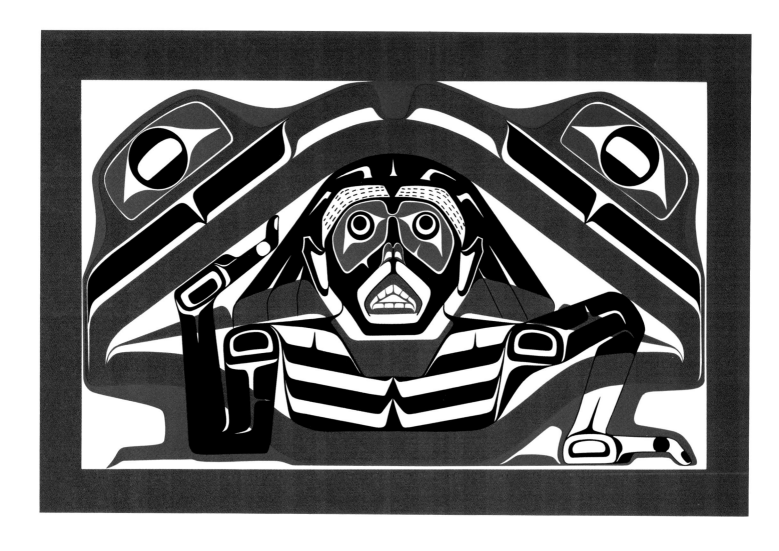

MAN FROG LEGEND / Doug Cranmer, *1978, edition 100, 61 x 91 cm;
red, black, and blue on buff*

Doug Cranmer's innovative Kwakiutl-style graphic shows a man who eventually became
a frog. Wearing the skin of a frog he had killed, this hunter prospered during a time of
scarcity but the frogskin became increasingly harder to remove. The man is shown in
Cranmer's print on the last occasion he was able to remove the frogskin.

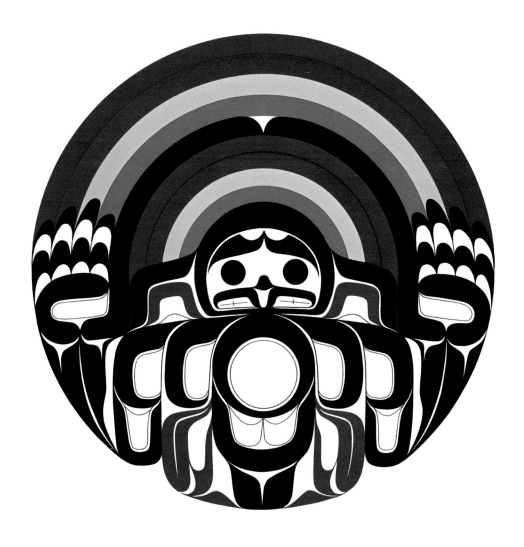

MEMORIAL RAINBOW DRUM / Joe David, *1977, edition 100, 61.5 x 48.5 cm;*
black, blue, red, yellow, and green on white

While driving home after his father's death, the artist saw a vision of a raven beneath a
double rainbow. This image was painted on a drum used at the memorial potlatch Joe
David hosted in honor of his father and was done as a silk screen design which was sold
to help finance the potlatch.

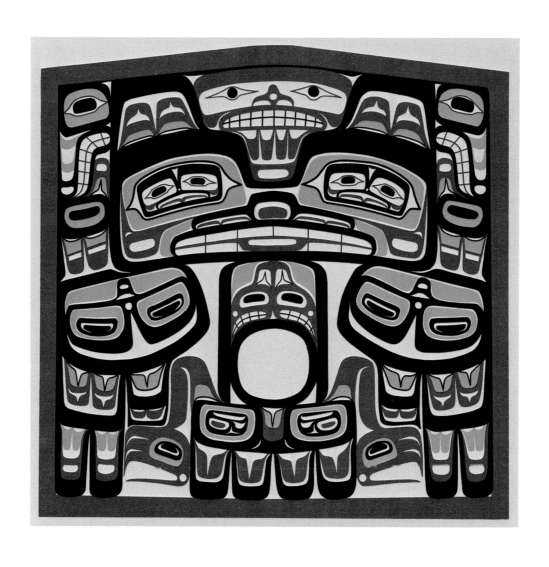

TLINGIT RAVEN DANCE SCREEN / Tony Hunt, *1977, edition 200, 48 x 48 cm; red, black, and blue-green on tan*

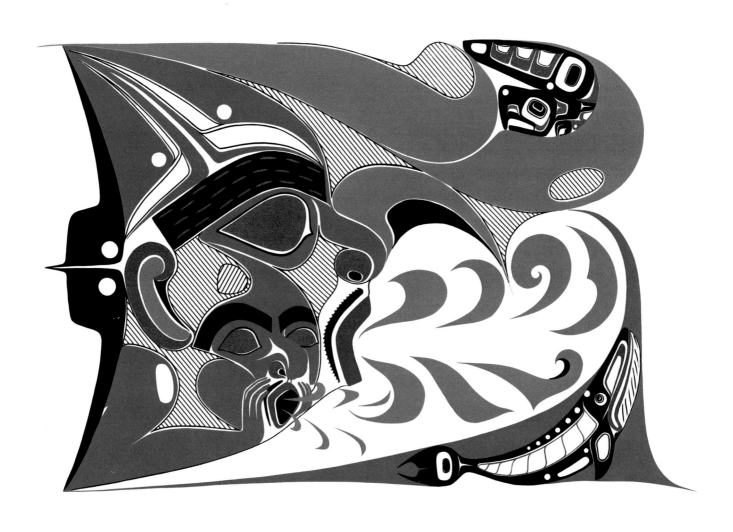

THE PREVAILING WIND / Barry Herem, 1978, edition 195, 46 x 67 cm;
blue, gray, black, and red on white

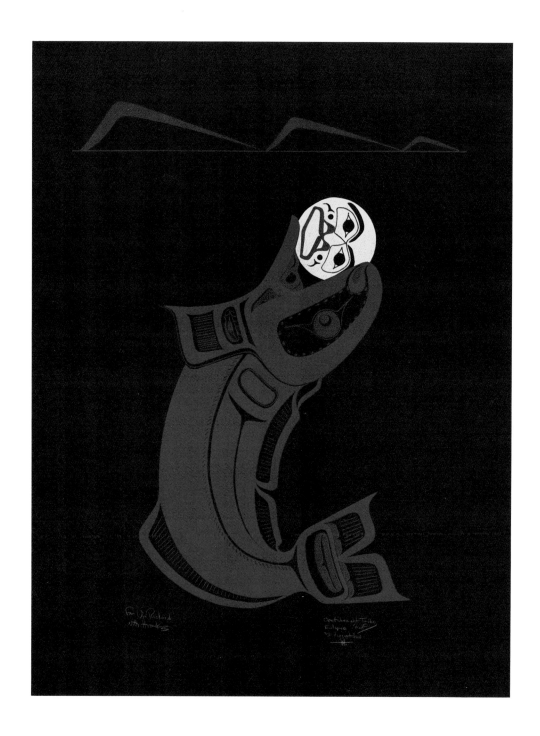

(ECLIPSE) / Hupquatchew, *(1972), edition 120, 61.5 x 47.0 cm;*
blue, red, and yellow on black

In Westcoast stories an eclipse was caused by a supernatural codfish swallowing the
moon. The darkened sky is emphasized by the black paper.

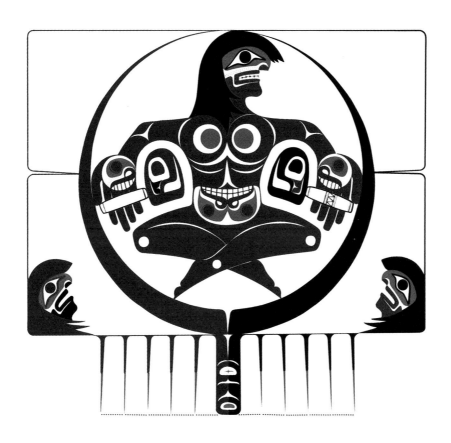

WEST COAST BONE GAME / Patrick Amos, *1979, edition 600, 47.5 x 51.0 cm;*
red, black, and blue on white

A popular winter leisure-time activity was a gambling game in which opponents tried to
guess the player's hand that held the marked bone.

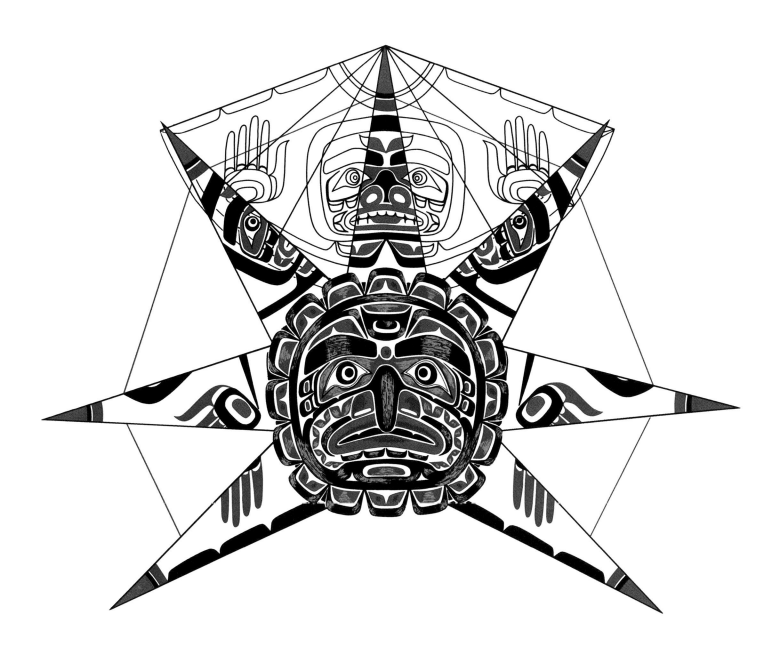

TRANSFORMATION SUN-MASK / Mark Henderson, *1978, edition 150, 51.0 x 64.5 cm; black, green, and red on white*

With this type of transformation mask, the dancer pulled a string to fan out the rays of the sun. The artist has graphically portrayed the after-image retained by the viewer's eyes following the transformation. The shaded edges of the mask impart a three-dimensional effect.

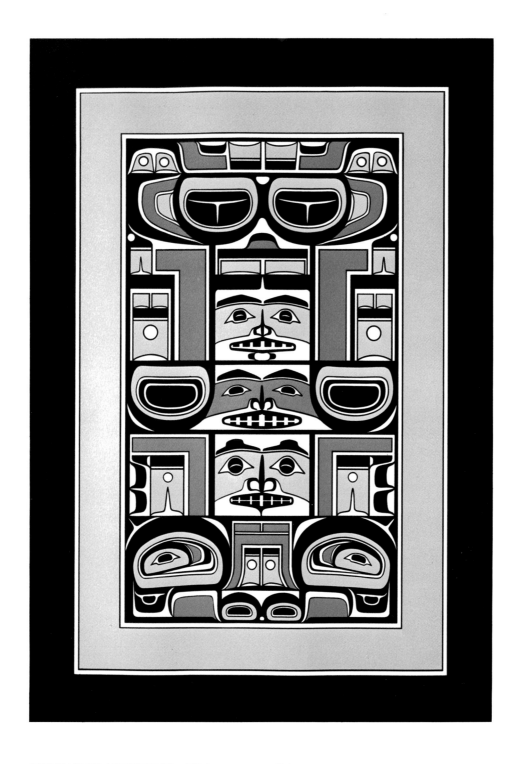

CHILKAT BLACKFISH / Roy Vickers, *1978, edition 75, 68.5 x 53.5 cm;*
black, yellow, and blue-green on buff

Vickers' 1978 Guild print depicts the blackfish, or killer whale, in Chilkat blanket de-
sign. The whale's head is at the bottom of the print, the tail at the top, and the split
dorsal fin along the side edges. The central column of three faces forms the whale's
body.

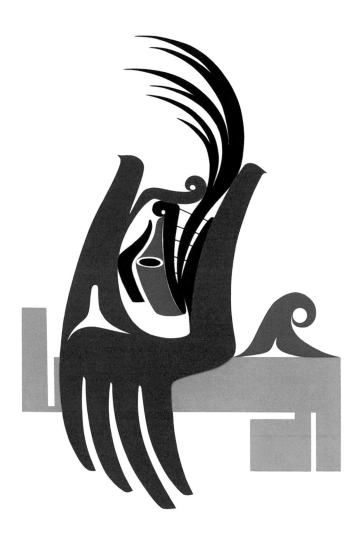

BARNACLE / Art Thompson, *1977, edition 100, 50 x 66 cm;*
red, green, black, and blue on white

Seldom if ever represented in the traditional art, barnacles were a food source reserved
for time of famine. This print is one of Thompson's Seafood series.

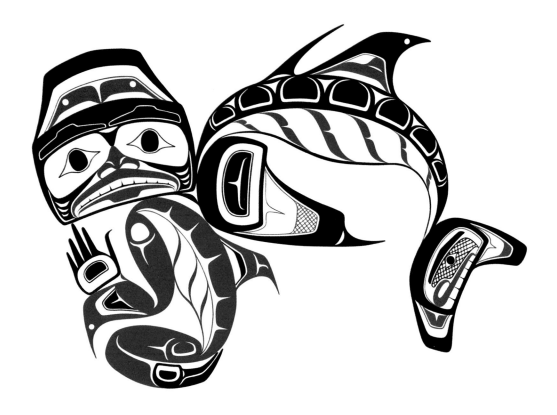

DOGFISH AND SPIRIT / Norman Tait, *1978, edition 75, 52 x 66 cm;*
black and red on buff

A classic Northern Northwest Coast design by a Nishga artist which shows a dogfish
shark and the humanoid spirit that inhabits the shark's body.

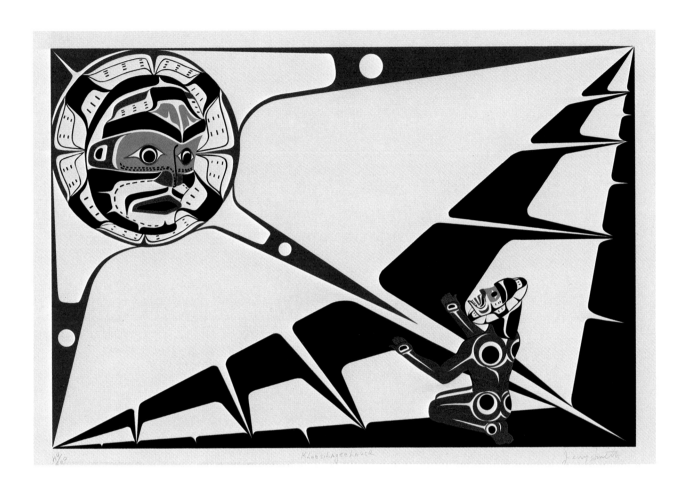

KLEESILAGEELAUCK / Jerry Smith, *(1977), edition 200, 40.5 x 58.5 cm;*
black, red, and green on ivory

Kleesilageelauck, the son of sun, went to visit his father but in so doing pushed the
clouds (his aunts) around. The sun's hot rays cracked the mountains (shown here as
black U-forms), Kleesilageelauck's uncles. Sun became angry, scolded his child, and
threw him back to earth. Smith's print shows the sun, the cracked mountains, and the
errant Kleesilageelauck.

DOGFISH CHEST, SIDE 2 / Duane Pasco, *1978, edition 150, 40.5 x 38.0 cm;*
red and black on buff

A classic Northwest Coast bentbox design. Pasco has used large areas of red to underlay
the black primary formlines.

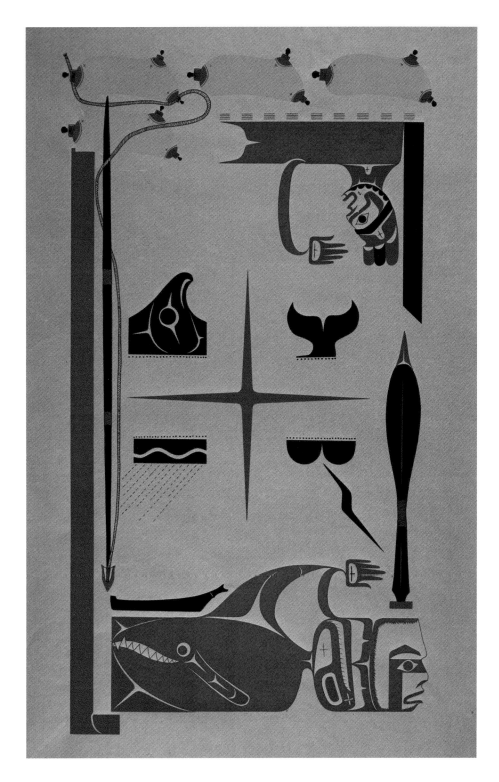

POO-WITSA / Hupquatchew, (1977), edition 75, 94 x 63 cm;
blue, red, black, and gold on brown

Part of the 1977 Guild collection, "The Whaler's Dream" presents a montage of images
that might flow through the mind of a Westcoast whaler in the days preceding a whale
hunt: weather signs, a diving whale, the image of a killer whale, the tides, and the para-
phernalia of hunting. The design was screened on a brown paper reminiscent of the
color of cedar boards.

Northwest Coast Indian Graphics

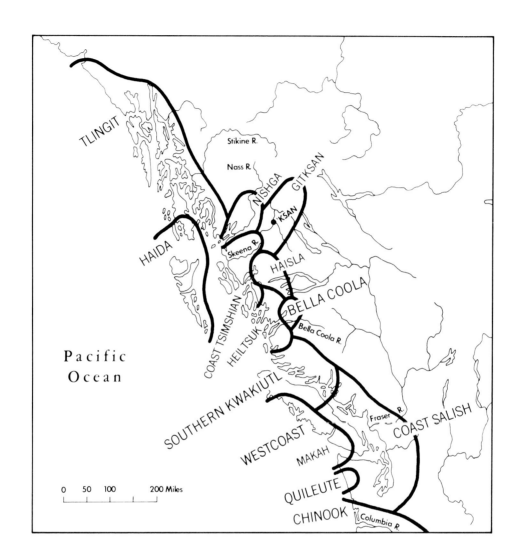

TLINGIT

Stikine R.

Nass R.

NISHGA

GITKSAN

KSAN

HAIDA

Skeena R.

HAISLA

BELLA COOLA

COAST TSIMSHIAN

Bella Coola R.

HEILTSUK

Pacific
Ocean

SOUTHERN KWAKIUTL

Fraser R.

COAST SALISH

WESTCOAST

MAKAH

0 50 100 200 Miles

QUILEUTE

CHINOOK

Columbia R.

Cultures of the Northwest Coast

Introduction

The forested expanse of sea coast extending from Oregon through British Columbia to Alaska was the traditional home of several Indian groups who developed an art form of startling power and remarkable sophistication. In recent years, contemporary expressions of traditional Northwest Coast Indian art in many different media have increasingly found an appreciative audience far beyond the boundaries of the Northwest Coast. The ancient totem poles that once towered above the plank house villages have rotted and returned to the forest or are preserved in museums, but newly carved totem poles grace native villages as well as such public centers as an industrial park in Vancouver, the grounds of an art gallery in Kansas City, a museum in Japan, and a hotel in Germany. Vibrant ceremonial masks that long ago spoke of the relationship between humans and the natural-supernatural universe now lie mute on museum shelves or pass under the auctioneer's hammer for tens of thousands of dollars, but contemporary Northwest Coast Indian artists create new masks that are as technically excellent and every bit as inspired, both to be sold to connoisseurs and to be used in modern-day ceremonies. Wide gold and silver bracelets engraved with stylized grizzly bears, killer whales, ravens, and other traditional designs are worn both by wealthy collectors and by Indian grandmothers, but not for the same reasons and with a different sense of pride. The contemporary Northwest Coast art scene radiates an excitement and enthusiasm similar to that which has developed elsewhere in North America as a result of the creative efforts of Inuit, Woodland, Southwestern, and other native artists.

Contemporary Northwest Coast Indian art combines traditional elements, motifs, and techniques with innovations both in design and in media. Nowhere are these current trends more apparent than in designs sold in the form of silk screens, or serigraphs, which are readily available from a variety of outlets in British Columbia and Seattle and from selected galleries across Canada and the United States. By utilizing the silk screen process, an artist is able to produce up to several hundred quality examples of an original design. As a result, many people can enjoy a Northwest Coast Indian work of art at a relatively low price; this would not be possible in the case of a unique creation such as a mask or bracelet. The following pages provide a general introduction to the traditional peoples of the Northwest Coast and their art, the relationship of traditional art to that being produced by contemporary artists, and the history and present status of Northwest Coast Indian design in the increasingly popular medium of serigraphy.

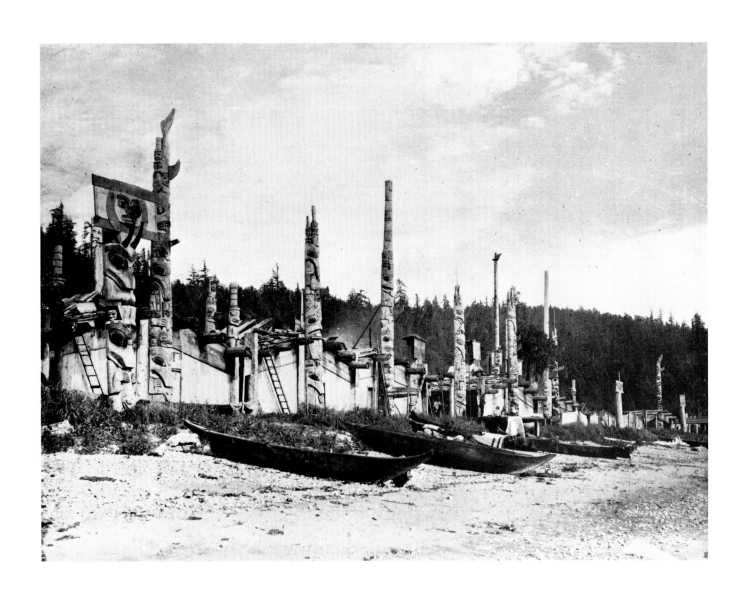

Skidegate, Queen Charlotte Islands, 1878. Photograph by George M. Dawson, courtesy of the Public Archives of Canada

The Traditional Cultures

Along the densely forested coastline and rivers of the Northwest Coast dwelt populations of hunting/gathering/fishing peoples whose cultural achievements and social complexity were unprecedented among the world's nonagricultural peoples. Although they spoke a diversity of languages, the several tribes inhabiting the Northwest Coast showed a considerable cultural homogeneity. As seen on the map (p. 26), Northwest Coast tribes included, from north to south: the Tlingit, the Haida, the Coast Tsimshian and the related Nishga and Gitksan, the Northern Kwakiutl (Haisla, Heiltsuk), the Bella Coola, the Southern Kwakiutl (also spelled Kwagulth and Kwagiutl), and the related Westcoast people (also known as the Nootka), the Makah, a dozen or so culturally and linguistically affiliated groups collectively referred to as the Coast Salish, the Quileute, and the Chinook.

In varying degrees these were ranked societies; that is, each individual had a position in the social hierarchy and, some say, in addition to individual ranking there were recognized classes of nobles and commoners. At the base of the social hierarchy was a castelike group of slaves who, as the unfortunate victims of war expeditions, became the chattels of the privileged. The drive to acquire ceremonial privileges and to amass and distribute native forms of wealth was the well-spring from which much of Northwest Coast culture derived. This quest for status and respect fueled not only the economy but ceremonial life and ritual, mythology, and art as well.

Native economies depended primarily upon abundant fish and shellfish, and for most groups salmon was the most important single food source (pp. 63 and 64). Sea mammals were hunted by groups inhabiting the outer coasts, though only the Westcoast peoples, the Makah, and the Quileute hunted whales (pp. 65 and 66). Seaweed, which was found in the intertidal zone along the beaches, was a widely traded and highly valued food.

The rain forests of the coast supported an abundant, if locally diverse, flora and fauna. Land fauna were of lesser importance than riverine and marine resources, but several groups hunted mountain goat and most sought deer, bear, and a variety of small fur bearers. The forests provided a bounty of plant foods and raw materials for native manufactures. A variety of berries, roots, and fresh greens were important food sources. Red and yellow cedar yielded a pliable inner bark that was utilized for clothing and basketry, and the roots of the Sitka spruce provided raw material for baskets, hats, snares, and fish traps. Cedar, particularly red cedar, provided timber for houses, canoes, storage boxes, and totem poles.

The Northwest Coast environment supported a relatively dense human population in precontact times with enough surplus resources to permit large numbers of people to live together for periods of several months. A village of substantial plank houses usually served as the winter home for upwards of a thousand people (p. 67). During the spring, summer, and fall months, villagers

dispersed to different camps where they fished, dug clams, collected cedar bark, hunted, and gathered berries and other resources.

Many resource areas were collectively owned properties, under the control of local groups. Composition of the local groups and method of affiliation varied from tribe to tribe, but everywhere members of a local group were related either by bilateral ties of kinship or by lineal descent from an ancestral founder. The local group generally owned salmon spawning streams, berry picking grounds, stretches of coastline, stands of cedar, and a winter village site. In addition to these economic properties, local groups possessed a corpus of stories and songs relating to the actual or mythological history of the group. The most important intangible group properties, however, were the ranked titles conferred upon its members. Among some tribes, titles were precisely graded, while among others perhaps only a first and second ranking title might be recognized, with the rest regarded only as either elevated or ordinary.

The holder of the highest ranking title was regarded as the chief of the local group and to him fell the direction of certain of the group's activities. He might decide when to depart for the salmon spawning streams or what lands to allocate for housebuilding, and he could call upon members to contribute to the potlatches which he gave on behalf of the group.

Local groups among the Kwakiutl, Bella Coola, and tribes farther north additionally owned "crests," or visual symbols, mostly animal forms, which served to identify the group and its members (p. 68). As noted later, crests were widely applied and displayed in Northwest Coast art. The Haida social system, for example, employed sixty-two distinct crests divided among forty-three groups. A number of these crests, most notably the eagle, raven, killer whale, and grizzly bear, were duplicated among several local groups (p. 69 and 70). This duplication was not necessarily exact, however, as some crests appear to have been highly specific; for example, two-finned, five-finned, and "raven-finned" killer whales were each crests of different local groups (p. 71). Most Haida local groups had three or four crests, but this number varied.

When the last of the fall salmon had been smoked and packed away in cedar boxes, the winter food stores were complete. The people, who had spent the last several months gathering and fishing, then returned by canoe to the winter villages (p. 72). If resources had been abundant, supplies would last until March, or even April, with a surplus for ceremonial use. Wintertime was the season when men made good their claims to rank and demonstrated their ceremonial prerogatives in dance (p. 17).

The most important and distinctive celebration of rank was the potlatch (from the Chinook trade jargon, meaning "to give"). Though the occasion for and mechanics of the actual ceremony differed from group to group, the potlatch universally was a ritual of recognition, a public validation of rank accomplished by the ceremonial distribution of wealth (p. 73). Typical occasions for hosting a potlatch included the building of a plank house, a marriage, the inheritance of a chiefly title, a death, and the conferral of names and rank upon one's children. The actual wealth distribution, which comprised only a portion of this complex ceremony, reaffirmed the rank of both the host and his guests. A man was known by the grandeur and size of his potlatches, and the rank of his guests was evident in the relative amount of wealth each received and in the order in which he received it. Potlatch distributions were punctuated by the

performance of dances, which entertained and displayed the host's privileges, and by feasting. Feasting also took place independently of the potlatch and likewise underscored the ranking system. An individual of high rank was expected to give frequent feasts to maintain the prestige of his high name and, when he did, he lavished his chiefly guests with an abundance of domestic and exotic delicacies.

For the Northwest Coast native, the line between human and spirit, human and animal, supernatural and natural, was not sharply drawn. Living human beings, for example, represented the reincarnated souls of deceased ancestors. Mythological beings, such as the creator-trickster Raven, transformed themselves back and forth from animal to human form (p. 74). Certain animal species were immortal. Returning to life after having been taken by the hunter or fisherman, they lived in communities whose social organization mirrored that of human communities. The killer whale "people" and the salmon "people" are perhaps the most frequently occurring examples. Many crests originated in an encounter and exchange between a human and an animal, after which the animal was adopted as a crest. The extreme of such communication is illustrated in the Northern Northwest Coast "Bear Mother" myth which tells of a woman who was abducted by a grizzly bear, raped, and later gave birth to half-human, half-bear twins. Many animal spirits also served shamans in their curing rituals, possessing the ritual doctor, conferring their powers upon him, and permitting him to diagnose and cure spirit-induced illnesses.

Masked dance performances united the human and spirit worlds (p. 75). Dances recreated ancestral or mythical encounters with spirit beings (p. 9). The most elaborate dance ceremonies on the Northwest Coast were held among the Southern Kwakiutl and are described by anthropologist Franz Boas, who witnessed them nearly ninety years ago (see *The Social Organization and Secret Societies of the Kwakiutl Indians*, Washington, D.C., 1897). The Kwakiutl believed that during the winter months spirits dwelt close to the villages where they revealed themselves and possessed the initiates of the several ranked dancing societies. So important were the dancing societies to the Kwakiutl that during the winter dance season the people laid aside their regular titles and assumed the names they had acquired through initiation in the dancing societies (p. 76).

Feasts and potlatches accompanied and validated the initiation of society members, and as part of the initiation ritual, masked dances were performed to return initiates to a state of normalcy, to demonstrate privileges, and to entertain the public. The masked dancers represented various mythological spirit beings and ancestors, and their elaborate and intricate masks were testimony to the sophistication of the carver's art.

Peoples to the north of the Southern Kwakiutl had many of the same dances, but none matched the complexity of the Kwakiutl winter ceremonies. Winter dancing was also important in Coast Salish society, but differed considerably from the Kwakiutl pattern. Dances and songs performed by the Coast Salish in their winter ceremonies represented powers conferred by individual guardian spirits, and the Salish masking tradition was not nearly as elaborate as that found to the north (p. 77).

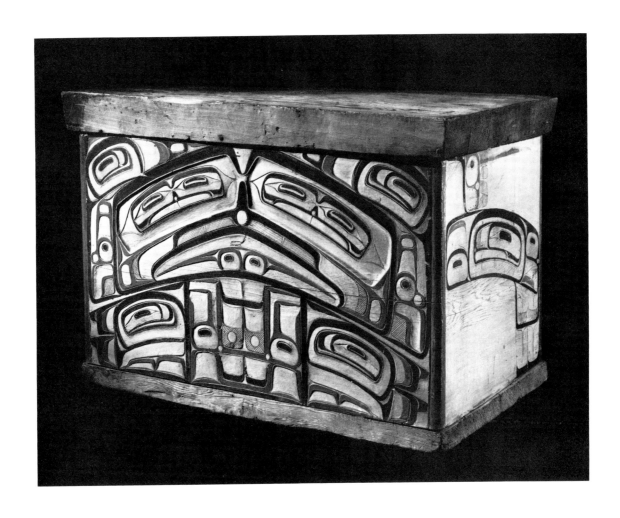

Northern Kwakiutl chest (coffin), collected by F. Jacobsen in 1893 at Bella Bella.
Photograph courtesy of the British Columbia Provincial Museum, Victoria, British
Columbia

The Traditional Art

Though traditional Northwest Coast art served the aesthetic tastes of the people for whom it was produced, its primary functions were social and ceremonial. Through the art the social standing of the individual and his group was advertised and elevated, and, often simultaneously, mythological personages and cosmological themes were depicted. Wood was the primary medium for the execution of the art and among those tribes whose social systems possessed crests, the art has appropriately been labeled a "crest art." The designs were applied to objects used in feasts, potlatches, winter dances, and shamanic curing as well as to architectural features within a village. The art appears on a multitude of objects, including feast dishes and spoons, chief's seats and screens, ceremonial blankets, drums, headdresses, masks, hats, helmets, boxes, weapons and tools, canoes and canoe paddles, shaman's rattles and charms, the human body (in the form of tattoos and painting), house fronts and timbers, and totem poles (pp. 78–80). Techniques used in executing Northwest Coast designs included painting, carving in shallow relief (often accompanied by painting), and three-dimensional carving.

The last technique wrought the most familiar artworks of Northwest Coast Indians and perhaps the most spectacular as well: monumental carved columns or totem poles (p. 81). Totem poles were carved by the Northern Northwest Coast peoples (Tlingit, Haida, Coast Tsimshian, Nishga, Gitksan, and Northern Kwakiutl) and in lesser numbers by the Bella Coola, Southern Kwakiutl, and Westcoast groups who acquired the technique from the Northern groups. Although the Salish produced the occasional carved inside house post, they did not carve totem poles. Imbued with symbolism, totem poles were keys to the social organization of Northwest Coast villages. Their carved, intertwined figures related the mythological origins of their owner's group or the mythical adventures of the group's crest animals, and perhaps advertised as well the crests of the pole owner and his spouse.

Totem poles were raised for a variety of purposes: as part of the house structure, to commemorate an important deceased individual or to serve as a container for his remains, and to elevate the status of an individual's children. Whatever the purpose, a pole raising was marked with a potlatch. The quality and intricacy of carving on a pole as well as the size of the pole itself testified to the wealth and greatness of its owner. The various poles on a man's property communicated information about the social organization and history of his household and local group and reminded all of his potlatching record. In addition, these elaborate columns were appreciated as works of art.

Crest animals as well as mythical beings were represented in masks used in the winter dances. These ranged in technical complexity from one-piece, simple human faces (portrait masks) to multiple part, movable masks. The transformation mask marks the culmination of technical virtuosity. Composed of two different visages, an outer one covering an inner face, this ceremonial mask dra-

matically demonstrates the belief in the ability of animals or humans to transmute. By pulling a string, the dancer opened the outer mask to reveal the inner figure (p. 18).

Shamanic art was comprised primarily of spirit representations. The shaman's spirit helpers, or beings from dreams and visions, were carved upon his many charms and his rattles. Not only embellished with art forms but embued with the power of the beings depicted, the shaman's rattles and charms were used in curing the sick, predicting the future, and bringing misfortune upon the enemy.

The Artist and His Patron

It has only been through the interest of museums in Northwest Coast art, beginning in the late nineteenth century, that attention has been paid by collectors and the larger public to the individual Northwest Coast artist and his works. Yet, while the traditional art has often been regarded as rigid and stylized, formal with little room for innovation, and tribal in style, the work of the individual artist was recognized in native society and was distinguished from that of his colleagues. The innovations were subtle: peculiarities of eye shape, repeated use of certain elements, acknowledged expertise in the representation of certain animal forms, etc., but the individual artist's pieces were unmistakable. Some artists achieved an "international" reputation. It was not uncommon for a renowned Haida carver, for example, to be commissioned by a Coast Tsimshian (and vice versa) to carve a totem pole, decorate a house front, or paint a screen.

The carved and painted art of the Northwest Coast was a male art; though masks and crest art were commissioned and owned by women, the art forms were executed by men. Women's art found expression in basketry and in the weaving of blankets. The Northwest Coast artist was a specialist, but not a fulltime specialist; like the rest of the people, he hunted and fished seasonally. It was only after museums commissioned large numbers of artworks during the late nineteenth and early twentieth centuries that the native cultures supported fulltime artists such as the master Haida carver, Charles Edenshaw. An artist generally began his career in his teens, apprenticing himself to an established artist. Apprentice and artist were often related by ties of kinship. An artist's career could be virtually lifelong, as Edenshaw's nearly sixty years of carving and painting testify.

The native patrons of traditional Northwest Coast art were the wealthy and high ranking: those who advertised their prerogatives and social standing in potlatching, feasting, dancing, and in the artistic symbols that accompanied these ceremonies. The art pieces they commissioned bore a direct relationship to their positions in the social hierarchy: a certain mask indicated membership in a particular dancing society; and the right to represent a certain figure on a totem pole reflected a specific chiefly prerogative.

Like his patron, the artist was also generally of high rank. The carving of crest animals and mythic episodes, and the representation of mythic beings in mask form, demanded knowledge of the creatures and myths depicted; such knowledge was generally cultivated by members of the upper echelons of society. An

artist was never his own patron; he always commissioned another to carve his totem poles, masks, and the other works of art that were requisite to his position in society.

The Development of the Art

A distinctive Northwest Coast art style can be traced to ancient stone carvings that have been unearthed at scattered locations along the Washington, British Columbian, and Alaskan coasts. The earliest accurately dated stone pieces, approximately 2,500 years of age, come from the northern British Columbia coast, though Northwest Coast art expert Wilson Duff believed the many stone images from the Fraser River valley to be from an even earlier period of time.

These earliest examples of Northwest Coast stone art are naturalistic carvings with suppression of minor detail and unembellished spaces. Anthropologist Philip Drucker labeled this sculptural style old Wakashan and saw it as the parent tradition for the carver's art of the Wakashan-speaking peoples (Kwakiutl and Westcoast) and the Salish. In the north, following the appearance of the Old Wakashan tradition there evolved a two-dimensional, surface-applied painter's art called the Northern Graphic tradition. Primarily a crest art, this tradition is evident in rudimentary form in prehistoric artifacts from the Coast Tsimshian area dating from about 2,000 years ago.

Northwest Coast art represented in museum collections (dating from the late eighteenth century to the turn of the twentieth century) shows the varying combinations of the Old Wakashan and Northern Graphic traditions attained in different regions of the Northwest Coast. Northern Northwest Coast art (Bella Coola northward) represents a combination in which the Northern Graphic tradition remained dominant, while Central Northwest Coast art reversed the order of this dominance; Coast Salish art was only minimally affected by the Northern Graphic tradition.

Following the mingling of the sculptural and graphic traditions, Northwest Coast art of the historic period was affected by several technological factors. Throughout the period of Euro-American contact, native Northwest Coast peoples have shown a pattern of opportunism in their receptivity to new items and ideas. If the item or idea in question offered an advantage either in terms of status or technological gains, it was generally adopted. This pattern is quite evident in the art. Richard Hunt, currently head carver at the Provincial Museum in Victoria, was well aware of this response to innovation when he quipped to a tourist who questioned his use of a small power saw to make cross cuts in a totem pole he was roughing out: "If our great grandfathers had had power saws they would have used them too."

In the late eighteenth century, European and American mariners plying Northwest Coast waters traded iron tools to the natives which in time replaced indigenous stone ones and greatly facilitated the carver's art. Commercial paint pigments were made available to native artists by the mid-nineteenth century and eventually replaced the native paints made from red ochre, graphite, charcoal, and copper sulfides. New colors and new shades were added to the painter's inventory. The most notable examples of the former are vermillion, used by all Northwest Coast groups, and the vibrant Reckett's blue (made from

a commercial laundry blueing agent), which came to be a preferred color of the Westcoast peoples.

By the mid-nineteenth century native Northwest Coast art burgeoned in new media. Argillite, a black slate found on the Queen Charlotte Islands and used for the occasional item in aboriginal times, became the medium of the first tourist art. As early as the 1820s, this soft stone was carved into figurines and pipes and later into miniature totem poles and boxes. Gold and silver coins pounded into bracelets, pendants, brooches, and earrings and engraved with crest designs supplied a native as well as a growing tourist market (p. 82). Beginning in the nineteenth century, wool and cotton fabrics were fashioned into ceremonial blankets appliqued with crest designs created by native men and sewn by native women.

Regional and Tribal Styles

The art forms of the Northwest Coast are often divided into three regional styles (Northern, Central, and Southern), and distinct tribal styles within each region can be recognized as well. Northern Northwest Coast art encompasses the painting and carving traditions of the Tlingit, Haida, Coast Tsimshian, Nishga, Gitksan, and Northern Kwakiutl (p. 21). Bella Coola two-dimensional art is usually regarded as Northern in style, while the sculptural forms produced by these people show more affiliation with Central Northwest Coast art. Southern Kwakiutl, Westcoast, and Makah traditions comprise Central Northwest Coast art, while the art forms of the Salish and peoples to the south of them are classified as Southern (pp. 10 and 83). Local usage in British Columbia often recognizes only a two-fold division of art styles: Northern and Southern. The Southern division includes both the Central and Southern divisions referred to in the classification used in this book.

Since much of the contemporary Northwest Coast silk screen design draws heavily upon the Northern style, it is instructive to consider the basic elements of this formal and conventionalized art. Its main distinguishing feature is the use of the formline, a curving line of varying thickness which outlines the contours of the subject matter depicted. Normally a design will have both primary and secondary formlines, distinguishable in dominance and in color; black is most commonly used for primary formlines, and red for secondary lines, though this order is occasionally reversed (p. 84). In addition to the formline, there are a number of stylistic elements based on or derived from it, including U-forms, S-shapes, and ovoids (ranging in shape from circles to rounded rectangles and including the more complex "salmon-trout-head"). The uses of these shapes in delineating eyes, joints, body parts, and hands are shown in Robert Davidson's box design (p. 37).

In all Northwest Coast art, but particularly in Northern art, animals and humans are represented by certain stylized conventions. Beaver, for example, has large incisor teeth, a cross-hatched tail, and often holds a stick in his paws (p. 85). Killer whale has teeth, a blunt snout, a blow hole, and a large dorsal fin (p. 86). Raven has a long straight beak, eagle a curved one, and hawk a sharply recurved beak. Over a hundred different animals were represented in the art, each distinct creature identifiable by such stylized features as these.

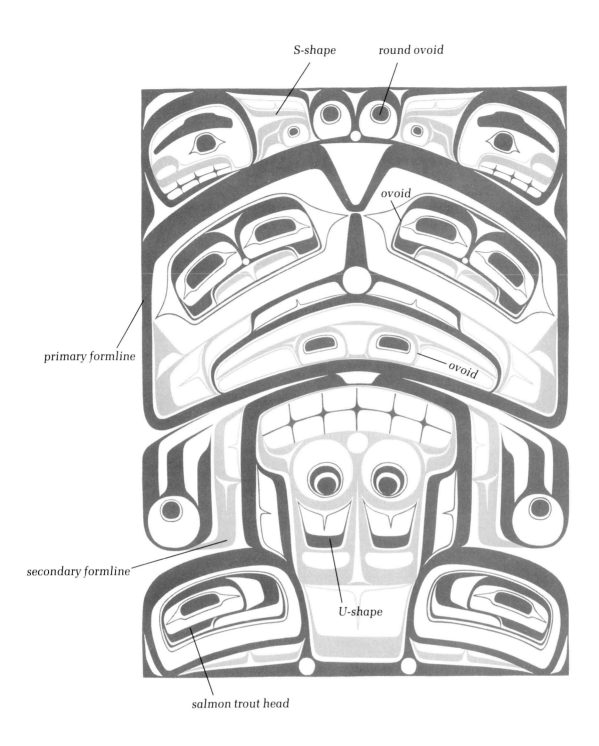

S-shape

round ovoid

ovoid

ovoid

primary formline

secondary formline

U-shape

salmon trout head

(BOX DESIGN) / Robert Davidson, (1970), 75 printed, 64.5 x 49.5 cm;
black and red on white

A classic bentbox back design. Note the various elements of the Northern style.

Northern Northwest Coast artists were concerned with filling all the space in the design field; thus, within the formline-defined subject, in addition to delineating body parts, some formline-related elements serve simply as space fillers. This "horror vacui" reached its greatest elaboraton in Chilkat Tlingit woven blankets, which were, in turn, patterned upon two-dimensional painted art.

Northern Northwest Coast two-dimensional art was adapted to conform to the shape of the object it decorated. To cover the design field the animal form often had to be distorted, split in half, or disjointed and rearranged. Often the animal is recognizable as in the split shark in Robert Davidson's design, but sometimes, most characteristically in Chilkat blanket designs, the splitting, disjointing, and distortion obscure the animal species represented (pp. 87 and 19). While the three-dimensional carvings of the various Northern Northwest Coast groups are usually distinguishable, their two-dimensional art was so similar that ascertaining tribal provenience of painted works is often difficult.

The art of the Central Northwest Coast peoples drew upon and incorporated the Northern Graphic Tradition, but the two-dimensional art from the central coast is quite distinct. In Southern Kwakiutl art, primary formlines may be thin and may vary considerably in thickness within a single line (p. 88). Ovoids can take a wider range of shapes (from sharp and angular to "soft"), and Kwakiutl artists used colors such as green and yellow seldom found in Northern art. Though concern for space filling and adaptation of motifs to the shape of the object decorated are evident in much Kwakiutl art, contemporary artists working in the style note that Kwakiutl art is not bound by the rigid rules of Northern art. Subject matter also differs. For example, peculiar to the Kwakiutl are the sisiutl, a double-headed serpent of awesome power, and several mythical human-eating birds whose representations were featured in the winter ceremonies (pp. 89 and 90). Tsonoqua or "Wild Woman" is prominent in both Kwakiutl and Westcoast mythology (p. 91).

Westcoast art shows less concern for filling space than Kwakiutl art. The formline and related elements are more freely applied, and use of color differs, with a preference shown for blue. Curlicues, dashes, four-way splits, and geometric borders are elements that contribute to the distinctiveness of the Westcoast style. Several mythical creatures repeatedly occur together in Westcoast art: the wolf, the thunderbird (and his assistants, the lightning serpents), and the favored prey of this mythical bird, the whale (pp. 92 and 93).

Decoration of ceremonial and utilitarian objects was not as common among the Coast Salish as among their northerly neighbors, though mat creasers, spindle whorls, and masks were sometimes embellished with shallow carved and painted designs (p. 94). Most contemporary Salish artists have not as yet drawn upon their traditional art in creating silk screen designs.

Post-Contact Cultures

A member of Vitus Bering's crew who went ashore in Tlingit territory in 1741 was perhaps the first European encountered by a Northwest Coast native. Not until after Capt. James Cook's circumnavigation of the world in 1778–80, though, did the European and American presence become a significant force in native life. Drawn to the Northwest Coast by the availability of sea otter pelts, which could be exchanged in China for silks, spices, and tea, numerous European and American mariners began to acquire sea otter furs from native hunters, to whom they traded a variety of manufactured goods (p. 95). For the most part this early maritime trade was peaceable and transitory. Traders seldom set foot in native villages. They appeared mainly during the summer months and collected furs from natives who came to the ships to trade.

Tlingit contact with traders differed somewhat from this pattern as the Russian-American Company controlled the sea otter trade at Sitka and Yakutat. By the turn of the nineteenth century permanent trading posts had been set up at these locations. Nor was the contact between Russian and native entirely peaceable: both the Sitka and Yakutat forts were destroyed by the natives within a few years after their establishment.

The plethora of goods acquired by natives during the maritime trade varied from year to year as exacting native tastes demanded changes. There were, however, staples which remained more or less consistently in demand for the duration of the trade. Sea otter furs could almost always be had in exchange for iron, guns, ammunition, blankets, and cloth. Yet, despite the taste natives acquired for the white man's liquor supplied them by the traders, the extra time expended in hunting sea otters and in trading, and the exotic imports, on the whole, native cultures were little altered by this initial contact.

With the valuable sea otter virtually eliminated through overhunting, the maritime traders disappeared from the Northwest Coast by 1830, and the trading interest was taken over by the powerful Hudson's Bay Company whose trading forts stretched from the Columbia in Washington to the Stikine in Alaska. The Hudson's Bay Company dealt mainly in land furbearing animals while continuing to supply natives with goods and foodstuffs introduced during the maritime trade period. The most important new item introduced by the company was its famed blanket, which soon became established as a standard of value all along the coast.

Unlike the seasonal mariners who preceded them, the Hudson's Bay Company traders were a permanent fixture on the Northwest Coast, but they too effected few cultural changes. The Hudson's Bay Company's interests were commercial, not social, and its traders sought peaceful trading relations and profit, not cultural revolution. Native groups generally benefited from the trade as they expanded their wealth through intensification of hunting and trapping. As Wilson Duff (1964) noted, more wealth meant more and larger pot-

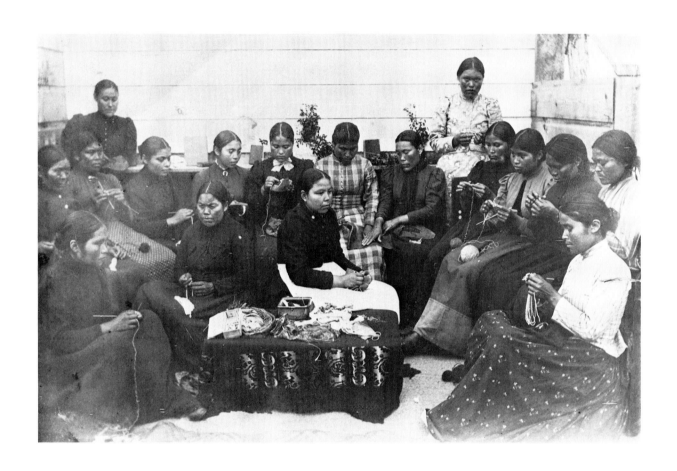

Indian women, sewing circle. Probably Tsimshian.
Photograph courtesy of the British Columbia Provincial Museum, Victoria, British Columbia

latches, a more active ceremonial life, and a greater need for artistic products. Thus, as a result both of the maritime and land-based fur trades, the art flourished.

The Hudson's Bay Company post at the new frontier town of Victoria, established in 1843, drew natives from as far away as Yakutat, the northernmost Tlingit settlement. Camping on the outskirts of town for extended periods of time, natives came to Victoria to trade their furs, purchase whiskey from illegal whiskey traders, and seek wage labor. Unfortunately, one of the more lucrative forms of wage labor was the prostitution of native women. Victoria brought few benefits to the many natives who camped there. There were intertribal rows and murders, arrests and jailings, venereal disease and resultant sterility, and worst of all, in 1862 there was smallpox. Some twenty-five years earlier smallpox had ravaged some coastal groups, mainly in Southeastern Alaska, but the 1862 epidemic was the single most devastating catastrophe to hit the natives of the Northwest Coast. Fleeing Victoria, canoeloads of infected Northern natives spread the disease as they made their way home to die. Within three years after the epidemic, entire villages were abandoned and the native population of the Northwest Coast was reduced to a mere third of its former numbers.

Missionary endeavors on the Northwest Coast began as early as 1795 with the establishment of the Russian-American Company's trading post among the Yakutat Tlingit (p. 96). The effects of this early missionizing were negligible, as the Russians won no Tlingit converts. However, by the 1840s a Russian Orthodox bishop at Sitka had baptized a hundred or so Tlingit, and along the southern Northwest Coast, Catholic priests were making forays from Hudson's Bay Company posts. In the 1860s the Anglicans and Methodists reached the Indians of the northern mainland British Columbia coast, and by the 1870s the Presbyterians had established themselves in the newly acquired United States territory of Alaska.

In addition to the inculcation of varying brands of Christianity, missionaries encouraged "civilized" dress, single-family, white-style dwellings, and the speaking of English, and discouraged or forbade totem pole raising and other "heathen" art forms, as well as potlatching, dancing, and the practice of shamanism. In Canada, the first two prohibitions found statutory support in a law passed by the government in 1884. Popularly referred to as the antipotlatch law, this statute forbade public gatherings involving the distribution of property or dancing. The law was increasingly enforced after the turn of the twentieth century. Violators were arrested, tried, and imprisoned, and potlatch wealth and ceremonial paraphernalia were confiscated. With the revision of Canada's Indian Act in 1951, the antipotlatch law was lifted.

Beginning in the late 1860s wage labor became increasingly important for native Northwest Coast peoples. In areas of the coast where white settlements had been established, native men worked as farmhands, and native women as domestics. Logging offered employment for native men, and women occasionally found work as logging camp cooks. The commercial fishery which began in the 1870s was, and has continued to be, the most significant source of wage labor for natives. Native fisherman successfully turned their ancient skills to commercial trolling and seining and supplied the labor force for the many canneries along the coast.

41

Few Northwest Coast groups signed treaties with the federal governments. Washington State Coast Salish ceded lands in exchange for reservations and other amenities in the mid-nineteenth century, and a few Salish groups in the vicinity of the Hudson's Bay Company post in Victoria relinquished lands through treaties signed about the same time; however, these groups are the exceptions. While they never formally relinquished their traditional lands, the remaining British Columbia natives were allotted reservations lands in the years between 1880 and 1908 (p. 97). Today, not surprisingly, the issue of land claims is of paramount concern to British Columbia's native peoples. No treaties were signed with Alaskan natives of the Northwest Coast, although the Tlingit and Haida reached a land settlement with the U.S. government in 1935 and received a monetary settlement as part of the 1971 Alaska Native Land Claims Settlement Act.

By the turn of the twentieth century, most native Northwest Coast people dressed in white-style clothing, lived in bungalows reminiscent of those in Victorian neighborhoods, attended church, favored gas-powered boats over canoes, and were described by missionary and Indian agent alike as "civilized." Today in native villages one sees modern housing, paved streets and streetlights, automobiles, and bicycles. Native children speak English and attend public schools; remote villages are connected to the outside world by telephone, television and by air service if not by road. The surface modernity belies the native character of these villages. A native identity emerges in the Indian languages softly spoken by a now elderly generation, in the potlatches, dance performances, and the feasts which punctuate the long, rainy winter months, and in the native works of art wrought by a young generation many of whom never witnessed the traditional ceremonies.

The changes in Northwest Coast cultures since the beginning of the twentieth century have been profound. Yet, in the rekindled pride in native heritage and the renaissance in ceremonialism and art, one can almost see the closing of a circle (p. 11). A Haida example underscores the irony of these changes. A Haida elder, born in the 1890s in the community of Masset on the northern Queen Charlotte Islands, while still a child saw the last of the totem poles cut down and sold, for one to two dollars per foot, to major museums, and then in 1969 watched Robert Davidson's magnificent new totem pole lifted into place beside the Anglican Church. One born in the 1890s might have played as a youth in the abandoned longhouses, seen as a young adult the last of these plank structures crumble into ruin, and years later attended the elaborate celebrations that marked the completion of two ceremonial longhouses built in the 1970s. The elder would have known a time when ceremonial button blankets were spurned by the Haida, sold to museums, or kept solely for their buttons, which were cut off and used on new clothing. Today on ceremonial occasions new and dramatic button blankets are proudly worn. A child of the 1890s might have known several occasions for potlatching, the most important of which followed the death of a high-ranking individual. The form of this mortuary potlatch was so affected by new funerary practices introduced by missionaries that an Indian agent could declare in 1912 that the Haida had given up potlatching long ago. No longer called a potlatch, the ceremony which followed the placing of a tombstone in the cemetery seemed almost wholly Anglican in appearance.

By 1975 the term *potlatch* had crept back into the native vocabulary, and these events are now celebrated for what they really are. During the Depression, the Haida elder would have witnessed the investiture of a new town chief carried on with no trace of native ceremony, but then would have watched in 1976 as native tradition was reinvented for the two-day installation ceremony of the new town chief.

The art forms of the Northwest Coast have seen parallel changes. By the beginning of the present century the Haida were no longer producing works of art for their own use. Charles Edenshaw, who once made ceremonial pieces for other natives, made his living after 1890 from museum commissions for ceremonial pieces of a bygone era. With only museum interest to keep the art alive, it appeared in danger of dying out. Surveying the state of contemporary Northwest Coast carving in 1961, anthropologist Harry Hawthorn wrote: "A later phase of the changes in Northwest Coast carving is its present decline; it can be labelled as nothing other than that" (*The Artist in Tribal Society* [1961]: 69-70). Fortunately, in respect to the creativity and virtuosity of native Northwest Coast art, we have indeed come full circle.

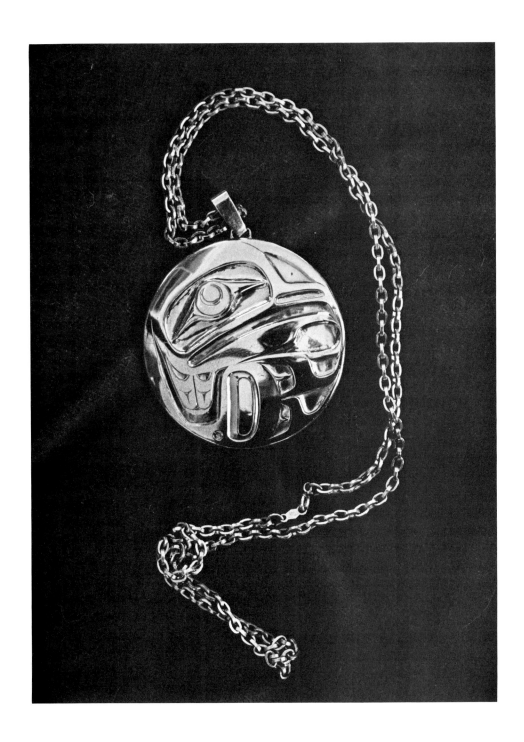

Gold pendant, eagle design. Robert Davidson, Haida, 1976. Compare with the design on p. 82 which is an adaptation of the pendant.

The Contemporary Art

The creative genius that underlay traditional Northwest Coast Indian art did not expire in the face of the depopulation, technological change, social disruption, and general cultural upheaval which so pervasively affected the Indians of the coast in the nineteenth and early twentieth centuries. Nor did visible expressions of the art completely disappear; in many villages the carving and painting of ritual objects continued, along with the songs and dances of the ancient ceremonies, though all in muted form.

A number of factors conspired against open expression of Northwest Coast art during this period. As part of their effort to supplant the indigenous religious beliefs with Christianity, missionaries railed against the ceremonies where ritual objects were worn or displayed and against the art itself. The Royal Canadian Mounted Police upheld the antipotlatch law by confiscating masks and other objects integral to the native ceremonies and by arresting the participants. Though the potlatch and its attendant art flourished in secret until the 1930s among some groups, particularly the Kwakiutl, and was never really completely supressed, the economic hardships of the Depression furthered the decline of both ceremonialism and the production of art in general.

A visitor to the Northwest Coast after the 1930s would have had to go to a museum to see an example of good Northwest Coast Indian art. A few high-quality traditional pieces still remained with their Indian owners, to be brought out at the occasional ceremony and displayed along with new objects created specifically for the occasion, but only the Indians, or the stray anthropologist or art expert, knew of the existence of either the old or the new. The interested outsider could not have easily purchased a quality piece of contemporary Northwest Coast Indian art. Though a curio market for objects of Northwest Coast art, particularly small carved argillite totem poles or figures, had begun in the 1820s, even these tourist items had declined in quality. Very occasionally, an artistically desirable piece appeared on the market prior to the mid-1960s, but the average tourist had to settle for a crudely carved, garishly painted model totem pole or canoe.

A revival, termed by some a renaissance, of Northwest Coast art began in the 1960s, accompanied, not coincidently, by a growing interest on the part of the Indians themselves in their past and a dramatic increase in ceremonialism. In many respects, the impetus for this revival was internal, arising from a growing realization that aspects of the old lifeways had value in the modern world. For certain groups, the revival was merely an intensification of an unbroken tradition that formerly had been hidden from the outside world; for others the past was lost and had to be reconstructed through reference to previously ignored elders, museum collections, and to scholarly descriptions of what once was (p. 98). The work of Bill Holm, author of the influential *Northwest Coast Indian Art: An Analysis of Form* (1965), was particularly important in this regard.

Renewed interest in Northwest Coast Indian culture and art was furthered by the efforts of the Museum of Anthropology at the University of British Columbia in Vancouver and the British Columbia Provincial Museum in Victoria. In 1950 the well-known Kwakiutl carver, Mungo Martin, was brought to the Museum of Anthropology to carve new totem poles and restore old specimens already in the museum collections. He was followed by Bill Reid, the master Haida artist, who reconstructed part of a Haida village, including a traditional house and totem poles, on the museum grounds. Doug Cranmer, another recognized Kwakiutl artist, was involved in these projects and, additionally, in the mid-1960s established the first native-run gallery to handle contemporary Northwest Coast Indian art.

Martin moved on in 1952 to the Provincial Museum, where he worked at restoring old totem poles, making replicas of others still standing at traditional villages or known only from old photographs, and building the traditional Kwakiutl house that stands beside the museum. The practice of having native artists work at the Provincial Museum, producing display items and creating masks and other ritual paraphernalia for use in contemporary ceremonies, has continued to the present. Martin was followed as head carver by Kwakiutl artist Henry Hunt, and he in turn by his sons, Tony and Richard Hunt. Thus, the museums in British Columbia have been directly involved in the rebirth of Northwest Coast Indian art.

An artistic revival also began in northern British Columbia in the 1950s with the creation of an Indian museum and craft village now known as 'Ksan. Originally a self-help effort on the part of the people in the Hazelton area, 'Ksan eventually received provincial and federal funding and has become both a cultural heritage center and a major focus of new development in Northern Northwest Coast art. The Kitanmax School of Northwest Coast Indian Art at 'Ksan has trained many local Gitksan and Carrier (a neighboring Athapaskan group) artists, as well as individuals representing various other coast groups, and thus is responsible for disseminating knowledge of both the technical aspects of artistic creation and the basic elements and motifs of Northern Northwest Coast style. The core of artists who have worked at 'Ksan since its opening has developed a distinctive contemporary style, grounded in classical Northern Northwest Coast art but personalized by innovations in design elements and subject matter. Furthermore, those associated with 'Ksan have made a concentrated and successful effort to integrate the revival in art with the recording and preserving of myths, family histories, songs, and ceremonies. This renewed interest in the past has led to artistic creations by 'Ksan artists which are sold to collectors and utilized in resurrected traditional ceremonies.

In the past fifteen years Northwest Coast Indian artists have been creating fine art pieces in many media which reflect links with the past and innovative design. Growing public acceptance of contemporary Northwest Coast Indian art has been evidenced in a number of ways. Major shows have presented the works of various artists: the 1971 Legacy exhibit at the British Columbia Provincial Museum featured pieces by artists representing several different Northwest Coast groups, and the 'Ksan artists displayed their creations at the Vancouver Centennial Museum and Planetarium in 1977. Within the past few years, many Northwest Coast Indians have also had individual shows. Spurred

on by the expanding market and in an effort to broaden their range of expression, native artists have begun to work in nontraditional media. As Northwest Coast Indian art has grown in popularity, prices have increased accordingly.

Modern Northwest Coast Indian art has become available at galleries and other retail outlets across North America. The interested collector can view and purchase massive totem poles, elaborate masks, carved and painted panels displaying animal crests, miniature totem poles and naturalistic figures of polished black argillite, gold and silver jewelry bearing traditional designs, and other fine works of contemporary art. Museums, business corporations, and wealthy collectors are commissioning major pieces such as totem poles and large carved panels. And increasingly, connoisseurs, as well as those just learning to appreciate the art's drama and beauty, are purchasing and enjoying original Northwest Coast Indian art produced in the form of silk screen prints.

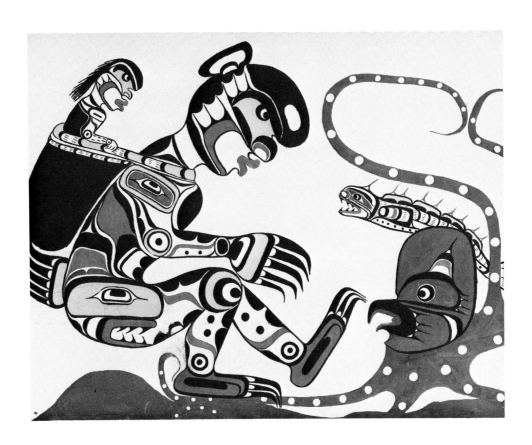

Mungo Martin. Sea tsonoqua carrying a baby on her back, backing away from an octopus and sculpin, watercolor. Photograph courtesy of the British Columbia Provincial Museum, Victoria, British Columbia

The History of Northwest Coast Prints

Much of the traditional Northwest Coast art was two-dimensional, with designs painted either on plain or carved flat surfaces or on three-dimensional shapes such as masks. Thus, the transition to designing on paper would seem to be natural. However, relatively few Northwest Coast Indian designs in any medium are known to have been done on paper prior to the 1950s. A few sketches were drawn at the request of anthropologists studying Northwest Coast Indian cultures; for example, around the turn of the century Charles Edenshaw drew tattoo designs for Franz Boas and blanket border designs for John Swanton. About the same time, Indians at the Alert Bay residential school began creating designs in poster paints. Many Indian artists have since executed their first designs on paper in a secondary school context, and some have been introduced to silk screen and other graphic techniques there.

Similar sporadic attempts at designing on paper occurred during succeeding years. However, in terms of the development of serigraphy as a medium for Northwest Coast Indian art, the first important paper designs were done by Mungo Martin, who created a series of colored pencil and watercolor drawings for the Museum of Anthropology at the University of British Columbia in 1949 or 1950. Later, while at the Provincial Museum, Martin painted a further series of watercolor designs depicting crest figures. Though he did not produce any silk screens himself, some of Martin's watercolors were publicly displayed, and specific designs have served as a direct inspiration for later artists working in serigraphy.

In the last thirty years, other Northwest Coast Indian artists have produced designs in various graphics media. Collections of native legends have been illustrated by Charlie George (Kwakiutl) and George Clutesi (Westcoast), and Bill Reid's (Haida) drawings accompany a Haida history written for young readers. Around 1965, Doug Cranmer produced press run block print designs on burlap cloth, and, somewhat earlier, Bill Reid did some prints by a method other than silk screening. More recently, some limited editions of prints have been lithographed and many "art cards" presently available on the market are also printed by this method. However, by far the most important graphics technique adopted by Northwest Coast Indian artists, in both commercial and artistic terms, has been that of silk screen printing.

Some question exists as to exactly when artists turned to serigraphy as a means of expressing Northwest Coast Indian design. Ellen Neel, a Kwakiutl artist, produced a number of commercially successful silk screened designs on cloth scarves beginning in 1949 (p. 51). A non-Indian, Charles Gruel, began making silk screen designs on rice paper about the same time or slightly later (p. 52). Although his designs were not very authentic, the prints were inexpensive and sold very well on the local tourist market; occasionally, Gruel prints can still be found in British Columbia shops. Beyond their historical interest, Gruel prints are important because some artists maintain that they began producing silk screen prints in reaction to Gruel's work, hoping to gain public appreciation of true Northwest Coast Indian design.

Sometime in the early 1960s Henry Speck, a Kwakiutl, created a number of original paintings depicting creatures from Kwakiutl mythology, and at least twelve of these were reproduced as unlimited silk screen editions (p. 53). It was not until 1965, however, that an artist who has continued to work consistently in the medium produced his first silk screen prints. Roy Vickers designed and printed three silk screen editions in his high school art class and sold them at the school art fair. At about the same time, Tony Hunt, in conjunction with the Women's Committee of the Victoria Art Gallery, published four or five silk screen designs.

In 1968 Robert Davidson initiated his prolific output in the medium, and Tony Hunt produced additional silk screen designs. Since then, serigraphy has become widely accepted as a commercially and artistically viable medium for Northwest Coast Indian design. Artists have realized that silk screens are ideal both for producing traditional Northwest Coast Indian designs and for creating contemporary designs drawing upon traditional motifs and styles. The public has responded to the increasing availability of prints by becoming more interested in, and more knowledgeable about, Northwest Coast Indian design. As a result of these interplaying forces, many Northwest Coast Indians (and some white artists working as well in Northwest Coast style) have turned to serigraphy as the major medium of expression for their art. By 1980 over 900 different designs by some 100 artists had been published as silk screen prints.

In 1977 a number of Northwest Coast native artists banded together to form the Northwest Coast Indian Artists Guild in an attempt to achieve international recognition for Northwest Coast art and Northwest Coast graphics in particular. The Guild's aims further included promoting high quality in design and workmanship and encouraging the continuing development of individual and regional native art styles. The Guild released a collection of nineteen silk screen prints in 1977 and a second collection of nine prints in 1978. Other special collections of Northwest Coast serigraphs have followed the Guild's model. A collection of twenty-four silk screen designs was produced by 'Ksan artists in 1978, and in 1979 the designs of ten native artists were released as "The Gallery Collection."

(RAVEN SCARF DESIGN) / Ellen Neel, *(1950s), edition unlimited; black on white*

51

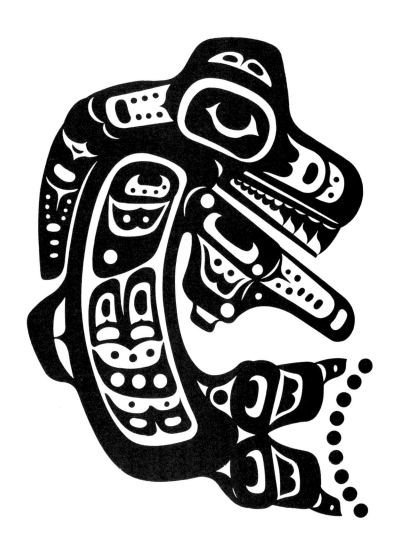

(KILLER WHALE) / Charles R. Gruel, *(1950s), edition unlimited; black on white*

An early, crudely executed silk screen print by non-native artist, Charles Gruel. Compare with the killer whales depicted on pages 71 and 87.

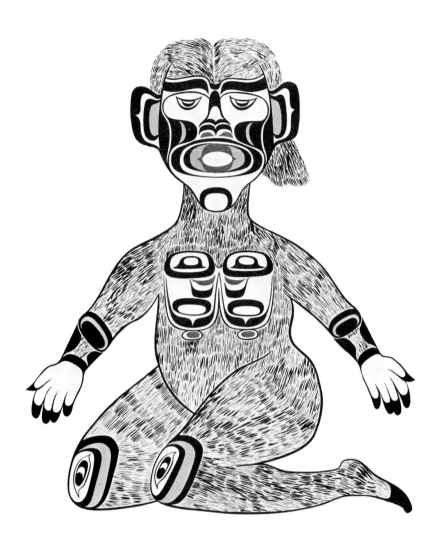

LADY GIANT: DSU-NU-GWA / Henry Speck, (1960s), edition unknown, 48 x 62 cm;
black, red, blue-green, olive green, and yellow on white

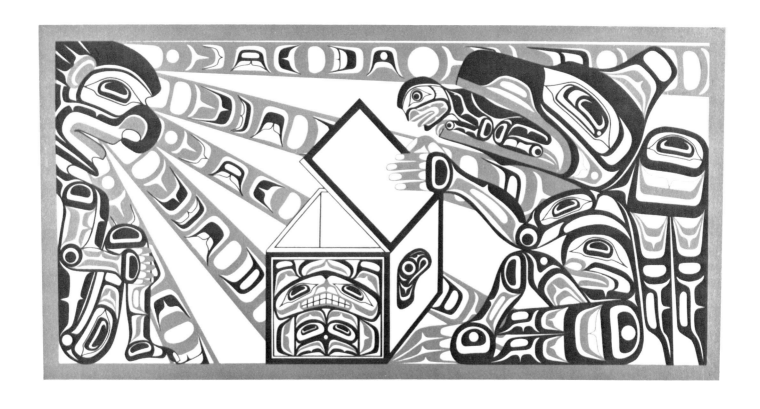

RAVEN RELEASING SUN / Calvin Hunt, *1978, edition 150, 40.5 x 64.5 cm;
red and black on beige*

Calvin Hunt's version of the classic Northwest Coast myth which details how Raven
brought daylight into the world was first done as a carved cedar panel and then rein-
terpreted as a serigraph.

54

Continuity and Change

Contemporary Northwest Coast artists have a wealth of traditional source material available upon which to draw in designing silk screen prints. For some artists, the oral traditions, learned as children, tell of mythological characters who take on visual form with the aid of the artist's brush (p. 99). The works of former masters, housed in museum collections, instruct and inspire a new generation and, for some masterpieces that have evaded the museum collectors, there are historical photographs. Village elders may advise and criticize, and there are books to relate the intricacies of ceremony and art unknown to even the oldest living natives.

Though all these sources are drawn upon extensively in the creation of modern works of art, contemporary Northwest Coast artists are obviously not bound to the creation of traditional works of art in the same way their predecessors were. The commercial market influences both the content and style of silk screen designs, but this influence is less limiting than the traditional system of patronage, which demanded specific subject matter of artists. Moreover, the medium of silk screen prints has facilitated certain innovations. A flat piece of paper offers a much freer design field than an object whose entire surface must be embellished with a particular crest animal. Modern commercial pigments present a wealth of new colors unavailable to even the late nineteenth century native artist. As a result, some modern Northwest Coast artists have boldly experimented with new colors, while others have explored the subtleties of various hues of the more traditional reds, greens, and blue-greens. Because of the complexity of factors affecting Northwest Coast silk screen art, one can find ample evidence of both continuity and change in the content and style of contemporary Northwest Coast two-dimensional design.

Content

The content of some artists' designs reflects a very personal view of both Northwest art and its function. In 1974 Roy Vickers published a silk screen design which was executed in accurate Northwest Coast style, but which depicted what appeared to be a Plains Indian holding a drawn bow and riding a horse (p. 100). At first the design was thought by some viewers to be a sophisticated art joke in that its content was not consonant with its style. However, the print was titled "First Horseman of the Apocalypse" and in reality reflected the artist's commitment to Christianity. Many of Vickers' subsequent silk screen designs have incorporated his religious feelings. In some cases, the influence is obvious, as with a head of Christ rendered in Northwest Coast style; in other designs a stylized cross, sometimes taking the form of the traditional Northwest Coast four-way split, has sufficed to make his point.

However, most Northwest Coast Indian artists have chosen to depict traditional crest and mythological figures in their silk screen designs, though they do not always portray these figures in traditional settings or in traditional ways. An analysis of 400 silk screen designs discloses the following pattern of specific figure representation: killer whale, 68; human, 58; Raven, 37; thunderbird, 28; wolf, 23; salmon, 22; eagle, 21; sun, 20; Weget (the Gitksan counterpart of Raven), 19; whale, 13; moon, 13; lightning snake, 12; frog, 11; dogfish-shark, 11; sisiutl, 10; and less frequently represented miscellaneous figures, 157 (pp. 101 and 12). Frequently one of the figures appears individually as the total design, as often was the case with traditional crest figures. In other designs, the figures appear in composite scenes; for example, 25 of the 68 representations of killer whale picture this mammal in conjunction with some other figure, and the same is true with almost all cases of human representation.

Thus, in silk screen designs it is possible to find ordinary killer whales depicted in a number of regional styles as well as supernatural varieties such as the two-finned and raven-finned killer whales. Beaver occurs in his traditional crest form and, in a more contemporary mode, within the walls of his house (p. 102). Raven releases the sun, as in the art of old, and is blown by a modern wind (pp. 54 and 103). The birth of Weget, a Gitksan culture hero, and the baptism of Christ are both rendered in Northwest Coast style (pp. 104 and 105).

Some subjects portrayed in silk screen designs were not depicted in the ethnographic art. Things foreign to the traditional culture, such as horses, cars, and guardian angels, are obvious examples. Shellfish, including barnacles, chitons, and mussels, which did not figure significantly in the traditional art, have also served as inspiration for Northwest Coast Indian artists (pp. 20 and 106). Certain monsters inhabited both the mythological world and traditional art, but others have found artistic substance only in the form of silk screen designs. Mythical beings like the *Bu-quis*, or wild man, for example, existed in the past only as masks or dances, but now they have been translated into two-dimensional design (p. 107).

The continuity that Northwest Coast Indians believed existed between the natural and supernatural world, and the interchangeability between human and animal, are reflected in the silk screen art. A bear is depicted in the process of changing into a human; Hanu-qwatchu is caught at the instant he is half-man and half-lingcod; a supernatural white wolf metamorphoses into a killer whale; and, in Tony Hunt's "Transformation Mural; Thunderbird, Raven, Whale, Eel and Eagle Man," various creatures are shown, one transforming into the next (pp. 108-10 and 74).

Most traditional Northwest Coast Indian art did not have a particularly erotic quality though occasional sculptural pieces clearly displayed sexual characteristics. Similarly, in a few silk screen designs the sex of humans or other creatures is indicated by stylistic or naturalistic depiction of sexual organs, but the overall effect is not especially sexually suggestive (p. 111). Tony Hunt's "Transformation" designs, however, are intentionally erotic, showing various elements of one creature penetrating the next during the process of transformation.

Artists also vary in the way they handle elapsed time. For some, a single-figure design can represent an entire myth with its flow of time and action (p. 22). Others capture a single instant within the flow of a long myth, or an ani-

mal's activity, or a dancer's movement; for these artists "before" and "after" exist, but the mind image they express as a design is a frozen second of life's continuum (p. 112). Still other artists collapse narrative time into a visual image, so that an entire myth is compressed into a single design by the use of linked design elements (p. 113).

Northwest Coast Indian artists have drawn on many sources for inspiration when designing for the silk screen medium. Their rich mythology offers endless opportunities for interpretation in two-dimensional design, and the majority of the silk screen designs produced by Northwest Coast Indian artists have mythological referents. Personal experiences also provide inspiration. A long, complex dream inspired an Art Thompson design, and the vision of a double rainbow over a raven resulted in a design by Joe David (p. 114 and 13). Observations from nature also appear in the silk screens; Art Thompson photographed a kingfisher in order to later render its diving form in Northwest Coast style, and Hupquatchew drew on his fishing experience to depict a naturalistic salmon (p. 115). Designs have been created to honor the dead, to raise money for a memorial potlatch, and to serve as gifts on that occasion. The ordination of a deacon and the investiture of a chief were marked by distribution of special silk screen designs (p. 116). Current events, such as the Commonwealth Games in Edmonton, spurred Roy Vickers to produce a commemorative design (p. 117). And finally, Barry Herem responded to a Picasso serigraph by doing his own interpretation in Northwest Coast style.

Style

The mere fact that one can recognize the regional or tribal identity of a Northwest Coast silk screen design is testimony to the continuity of traditional styles. Bill Reid, Robert Davidson, Norman Tait, and Freda Diesing produce designs in the best modes of the restrained, classic Northern style. The vibrant colors, repeated rows of S-shapes and U-forms, and the soft ovoids identify as Kwakiutl the work of such artists as Richard Hunt and Mark Henderson. Circular motifs, geometric borders, dashes and curlicues, among other elements, readily mark Joe David's, Hupquatchew's, Tim Paul's, and Art Thompson's prints as Westcoast. All of these artists, and others, are designing in the traditional styles of their forebearers.

Some artists also work comfortably in more than one distinct style. Tony Hunt, for example, designs not only in his native Kwakiutl style but occasionally in the style of the Tlingit to whom he also traces his heritage (p. 14). Joe David has been particularly eclectic during the course of his artistic career. Before turning to his native Westcoast tradition, he began his silk screen career with designs that were quite Northern in appearance. David's carving has shown a similar range with the production of pieces in Tsimshian, Bella Coola, and Westcoast styles.

Other artists have incorporated more than one regional/tribal style in a single two-dimensional design. Beau Dick, for example, has produced designs that combine Kwakiutl and Northern styles (p. 118). Individual elements have a very Northern appearance, but the overall effect in these designs is distinctly Kwakiutl.

Northwest Coast artists have expressed, both in their works and verbally, varying degrees of discomfort in breaking away from traditional styles. Bill Reid is particularly conservative in his approach to Haida art. He notes that traditional Haida flat design typically depicted only single creatures, and he continues to follow this tradition in his silk screen prints. Reid goes even further, reminding us that Northern designs were always applied art and that to place such designs arbitrarily in the middle of a design field somehow runs counter to tradition. To connoisseurs of the art this evidently doesn't matter, for Reid's designs have become established not only as fine Northwest Coast art, but as fine art. Other Northern artists, less conservative than Reid, still feel uneasy bending or breaking the "rules" of traditional Northern style. Art Sterritt, a 'Ksan artist, commented: "It's always sort of in your mind that if you can't carve a design or apply it to wood, it's not quite correct. It's not quite Northwest Coast design."

Some artists have wandered far afield of traditional design. Barry Herem, a white artist from Seattle, draws upon traditional Northern Northwest Coast art and mythology to create contemporary graphics designs different from those being done by native artists (p. 15). More influential on native Northwest Coast art has been the work of Vernon Stephens at 'Ksan. Stephens was the first of the 'Ksan-trained artists to use traditional formline elements to impart a naturalism to human and animal figures. Stephens' personal influence is evident in many of the current prints being produced at 'Ksan, as well as in the work of earlier 'Ksan-trained artists such as Roy Vickers (p. 119).

One of the most prominent "new" Northwest Coast art styles is that of 'Ksan, which developed in the years following the founding of the Kitanmax School of Art. In her book, *Looking at Indian Art of the Northwest Coast*, Hilary Stewart describes 'Ksan art in both emotive and stylistic terms. She notes that the traditional Northern stylistic elements (U's, S's, etc.) are elongated or abbreviated and often detached from the main body of the design. Much of 'Ksan two-dimensional design is angular, and what was once a tension bound art, contained and confined to the objects it decorated, literally explodes in sweeping, dramatic formlines.

Several Westcoast artists through their silk screen designs have redefined a Westcoast style. Modern Westcoast art draws upon a number of traditional motifs, noted earlier, and upon innovations introduced by several artists working in the style. Joe David, for example, has taken the Northern formline and imparted to it a sense of movement and fluidity not evident in Northern Northwest Coast art. Appropriately, he has labeled his creation "the fluid or liquid line" (p. 120). David has also employed thin lines as part of his designs. Tim Paul, in a recent print, adapted the geometric border shapes typical of the old Westcoast art to delineate internal features of his design (p. 121). Art Thompson has freely borrowed Northern elements, using formline derived shapes to depict naturalistic features such as rocks and stream bottoms, and has modified Northern ovoids and salmon trout heads to fit his Westcoast designs (p. 122). Although most Northern Northwest Coast artists working outside the 'Ksan style have produced largely traditional designs, there have been innovators working with the conservative Northern tradition. For example, Robert Davidson, and others following his lead, have recently employed thin lines or other secondary elements as primary formlines (p. 123). Despite such innovations,

Northern non-'Ksan art is unquestionably more conservative than the contemporary art from any other region of the Northwest Coast.

A number of artists working in different ethnic styles have been innovative in using perspective in their design. Perspective was rarely shown in traditional flat Northwest Coast art and then only by the overlapping of elements. Tony Hunt's "Transformation" series exemplifies this more traditional rendering of depth perspective but, in this case, the overlapping is specifically employed to convey the themes of transmutation and eroticism rather than to impart a third dimension to the designs. Ken Mowatt's rendering of the canoe in "Weget and Hala-laa," on the other hand, clearly suggests a third dimension (p. 124).

Silk screen technology itself has offered numerous avenues for experimentation in Northwest Coast art. The printing inks range from dull to glossy and colors vary from thin and transparent to thick and opaque. Various stencil making techniques allow a wide range of textural effects and deep, rich colors can be achieved because the ink lies on the paper surface rather than being absorbed. The serigraph artist can select from an almost infinite array of ink colors and from a broad range of paper colors and textures. Several artists have experimented with ink variations of the traditional native red. At least six different shades of red are employed in work printed for Northwest Coast artists, ranging from the commercially produced fire-red through specially mixed shades of truer red and red-browns. Duane Pasco, who favors red-brown, has used it in bold color blocks to overlay areas of black primary formlines, a technique first employed by a few innovative Northern artists of the nineteenth century (p. 23). Some artists have utilized wholly nontraditional colors in their prints. Art Thompson has frequently used color to impart a realism to his designs. Thus "Sea Urchin" has a pink "mouth," and "Rainbow," hair of deep blue, yellow, green, and red (p. 125). Some artists, most notably Barry Herem, have experimented with metallic colors. Herem's "Power of the Shining Heavens," originally designed as a poster for Alaska Airlines, utilizes copper, gold, and silver (p. 126). Other innovations include the use of gray as a secondary and white as a primary color.

The silk screen process also invites experimentation with the application of color. In order to achieve a textured effect, Robert Davidson has overlaid colors in certain areas of designs (p. 127). Vernon Stephens, in a bold move, silk-screened a print which appears in the 1978 'Ksan collection in a three color wash, putting black, blue-green, and red simultaneously on the screen (p. 128). This technique resulted in a unique print with each sweep of the squeegee across the screen.

Paper color and texture have also added new dimensions to Northwest Coast flat art. For Hupquatchew the design field color has been particularly important. His "Eclipse" was printed on black paper to denote the effect of the supernatural codfish swallowing the sun or moon (p. 16). Two of Hupquatchew's 1977 Guild edition prints were screened onto a Japanese paper whose color resembled the natural cedar boards on which traditional flat art was rendered (p. 24). Paper texture has also played a role in the effect of a design. Ken Mowatt has been especially interested in the interaction between design and paper, and for that reason has often selected a mulberry paper whose suppleness enhances and complements the motion of his designs.

AHOUSAT MEMORIAL / Hupquatchew, 1978, edition 10, 57 x 76 cm;
black, blue, light blue, red, pink, yellow, purple, and green on white

Hupquatchew's eight-color print captures the natural hues of the rainbow. The print
honors seven persons who perished in a house fire in the Westcoast village of Ahousat.

60

Conclusion

Although the aesthetic satisfaction a modern native artist derives from creating a new design may vary little from that experienced by his ancestors, contemporary Northwest Coast Indian silk screen art serves ends far removed from the socio-ceremonial applications of traditional Northwest Coast flat art. While some silk screen prints have been created strictly for use as commemorative prints and/or potlatch gifts in the native communities, Northwest Coast silk screen art is first and foremost a public art. Artists produce designs with the knowledge that their work will be marketed to a diverse audience, and many artists, though they work in other media as well, derive a substantial portion of their livelihood from the sale of their silk screen designs. The commercial nature of the art is further evidenced by the fact that a few native artists see silk screens as the only medium appropriate for marketing Northwest Coast Indian design to the public.

For those who purchase and enjoy Northwest Coast silk screen prints as well as for the artists who create the designs, there are two especially significant features of the art. As noted earlier, the silk screen medium has allowed artists to innovate and experiment in design and color in ways impossible in any other media. For this reason, Northwest Coast silk screen design represents the vanguard of contemporary Northwest Coast Indian art. Second, because of the nature of silk screen art, especially the capacity to reproduce a design in multiples and the relative affordability of individual prints, the process has become the art form through which the native artist can best communicate to the public something of his or her native heritage and personal values.

CLAM / Art Thompson, *1977, edition 100, 50 x 66 cm;*
blue, green, red, and black on white

Part of Thompson's "Seafood series" of five prints, clam is depicted here as a male.
Clams and other intertidal resources were important in traditional Northwest Coast
native economies.

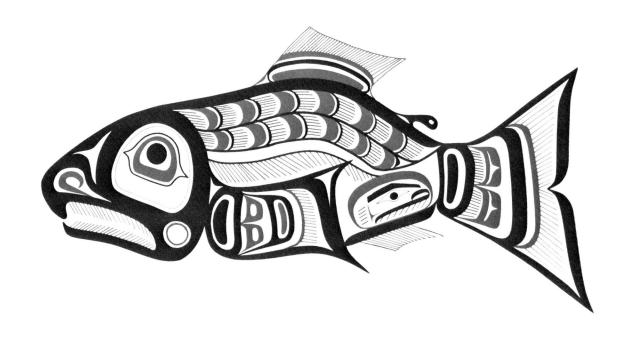

KWAGULTH SALMON / Tony Hunt, 1976, edition 50, 29.0 x 44.5 cm;
black and red on white

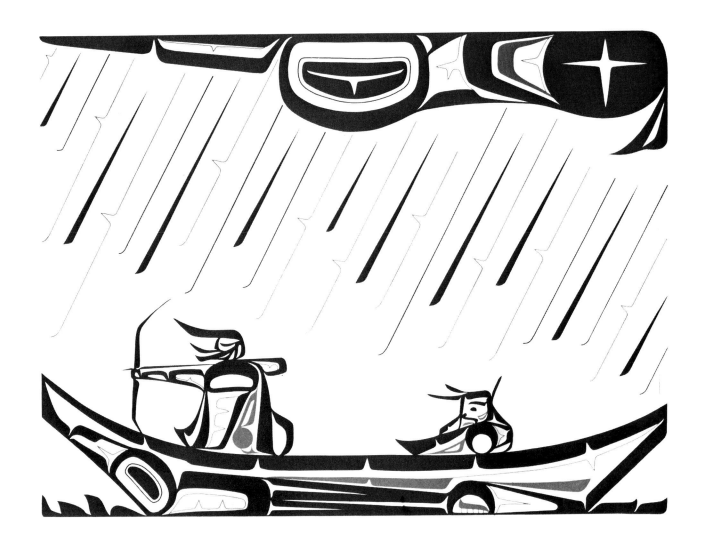

OOLA! OOLA! SEAL! SEAL! / Roy Vickers, 1975, edition 50, 40.5 x 51.0 cm;
black and red on white

Hunted by most coastal dwelling groups, seals were typically harpooned by a hunter
stationed in a small canoe. A short bow, like that shown here, was occasionally used in
seal hunting.

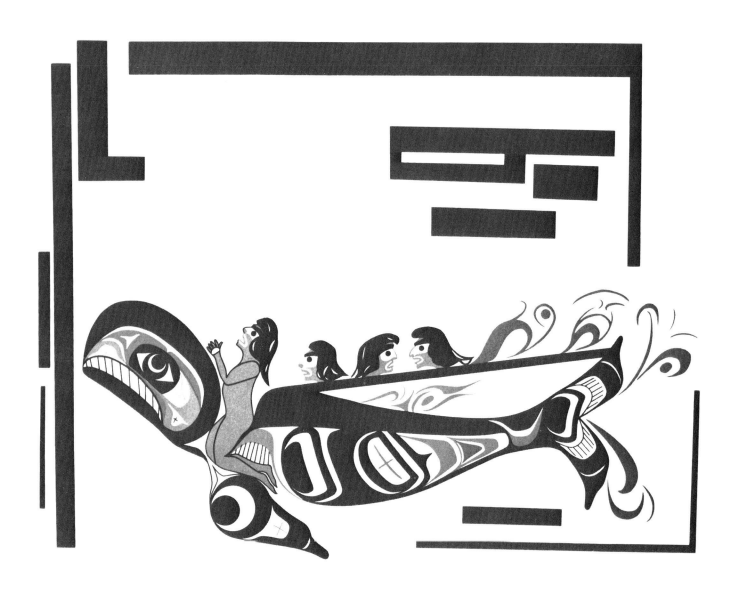

GRAY WHALE AND NOOTKA WHALERS / Tim Paul, *1977, edition 152,*
40.5 x 46.0 cm; black, red, and blue on white

California gray whales were often hunted by Westcoast people. The whalers' canoe is
shown behind the harpooned whale, and one whaler is preparing to sew up the dead
whale's mouth to prevent the leviathan from sinking.

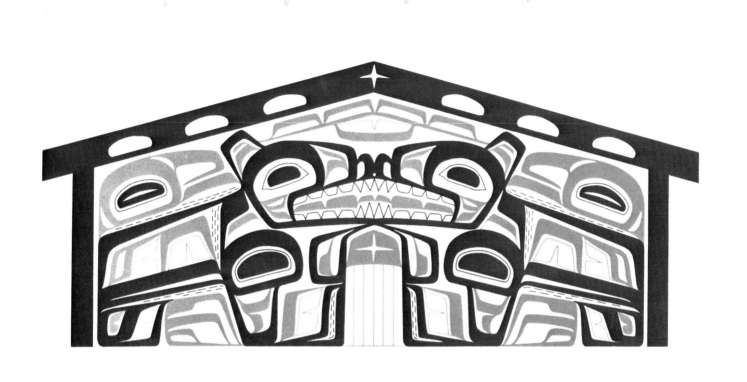

HOUSE OF WOLVES / Roy Vickers, *1976, edition 80, 33 x 51 cm; black and red on tan*

Traditional Tsimshian house fronts often were painted with the owner's crest as in this design which shows a split wolf. The roof beams and doorway are clearly indicated. The four-way split (a stylized cross, from the artist's point of view) at the roof peak is more common in Westcoast than in Tsimshian art.

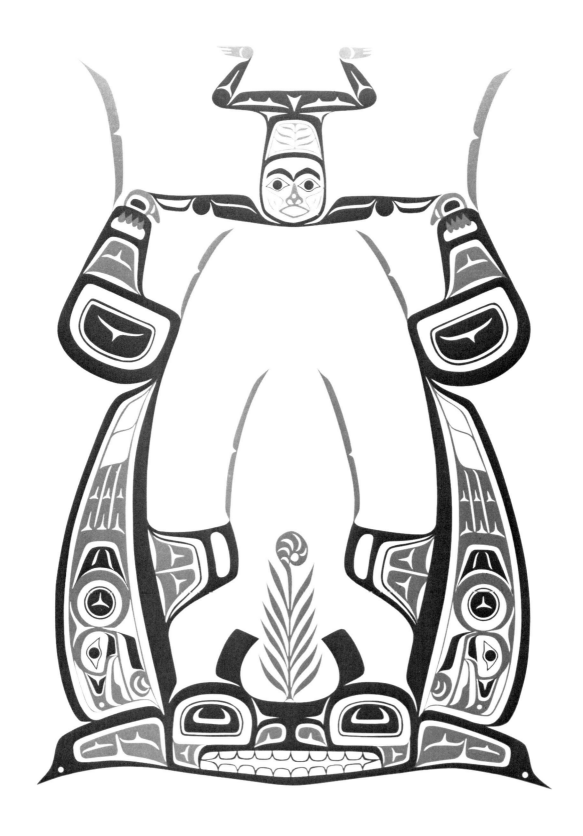

GITKSAN CRESTS OF THE FIREWEED CLAN / Walter Harris, (1977), edition 100, 76 x 56 cm; black and red on white

In this print artist Walter Harris illustrates the crests of his group: killer whale, fireweed (sprouting from the whale's blowhole), and grouse (in the whale's body).

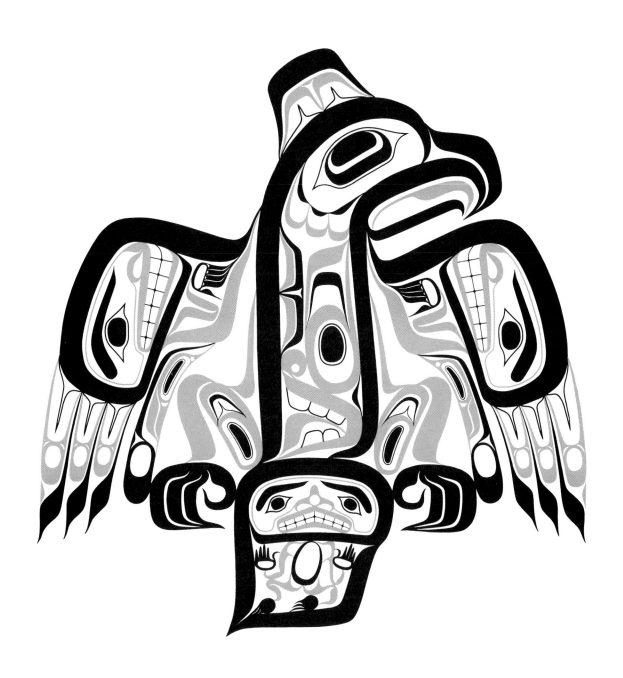

HAIDA EAGLE / Bill Reid, *1978, edition 195, 56 x 76 cm; black and red on buff*

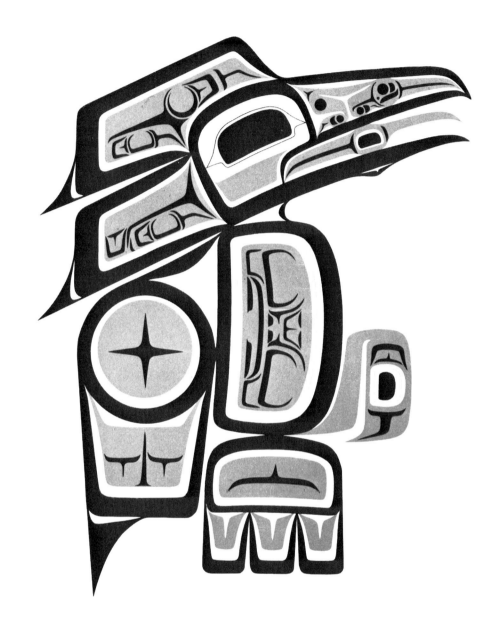

(RAVEN) / Francis Williams, *1973, edition 100, 59.0 x 44.5 cm; black and red on tan*

This classic raven design by Haida artist Francis Williams derives from an old Tlingit screen. The secondary red filler is reminiscent of red cloth applique used on Northern ceremonial blankets.

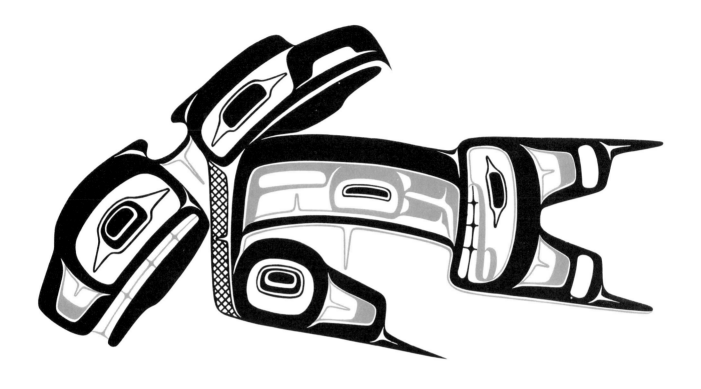

RAVEN-FINNED KILLER WHALE / Robert Davidson, *1978, edition 75, 28 x 42 cm;*
black and red on buff

One of several mythical Haida killer whales and a crest figure, raven-finned killer whale
has a raven's beak for a dorsal fin. Robert Davidson has been innovative in elevating
secondary or tertiary elements to primary status as he has done in this print with the
cross-hatched U-forms. Davidson's killer whale was part of the 1978 Northwest Coast
Indian Artists Guild collection.

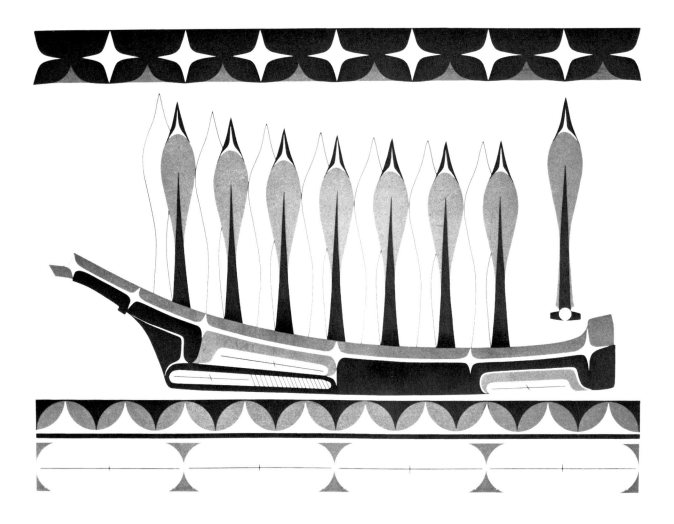

MEMORIAL CANOE / Joe David, *1977, edition 100, 48.5 x 61.5 cm;*
black, blue, and red on white

Northwest Coast natives developed an unparalleled sophistication and skill in wood-
working. Large canoes were fashioned from red cedar logs which had been hollowed out
to uniform thickness and shaped by steaming. This design was created by the artist to
honor his father. A solid blue version was distributed to guests at a memorial potlatch,
while the three-colored version was sold to raise funds for the potlatch. The typical
Westcoast canoe recalls the carving prowess of the artist's father; the stars represent his
"crest"; the seven positive paddles stand for the artist and his six living siblings and the
seven silhouette paddles, those siblings who have died. The solitary paddle in the stern
represents the artist's father.

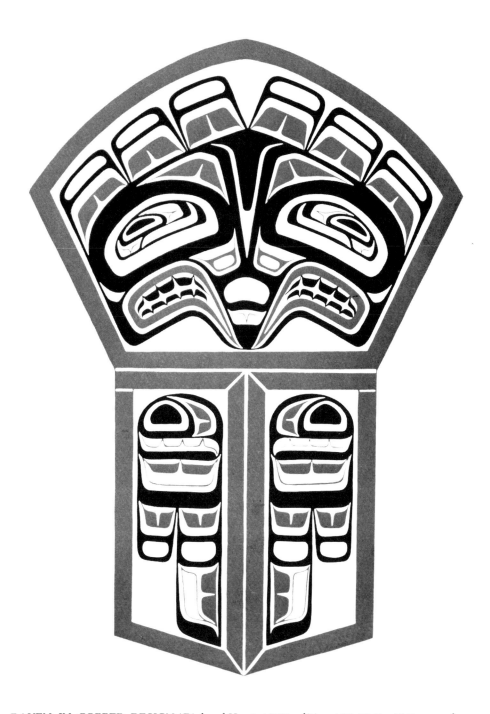

RAVEN IN COPPER DESIGN / Richard Hunt, *1977, edition 100, 59.5 x 40.5 cm; red and black on white*

The copper, a native wealth item, achieved special significance in Kwakiutl culture. Made of sheet copper with a raised "T" in the center and often embellished with an animal design, each copper was named and individually valued. A copper was often offered for sale to raise capital for a potlatch, and, sometimes, the ritual of its sale might be part of the potlatch proceedings. Coppers were always offered to rivals; refusal to purchase was admission of defeat. A copper increased in value each time it was sold. By the turn of the twentieth century, many were valued in the thousands of dollars. Richard Hunt's design was done as a poster advertising an anthropology conference.

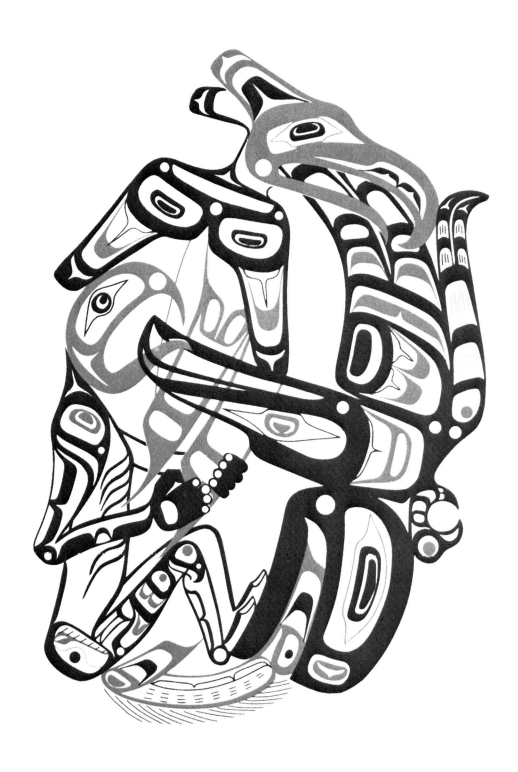

TRANSFORMATION MURAL: THUNDERBIRD, RAVEN, WHALE, EEL AND
EAGLE MAN / Tony Hunt, *1976, edition 200; black and red on medium brown*

Various mythological creatures transform one into another through the technologically
sophisticated use of opposing color and overlapping. The artist acknowledges an
intended erotic element in this particular design.

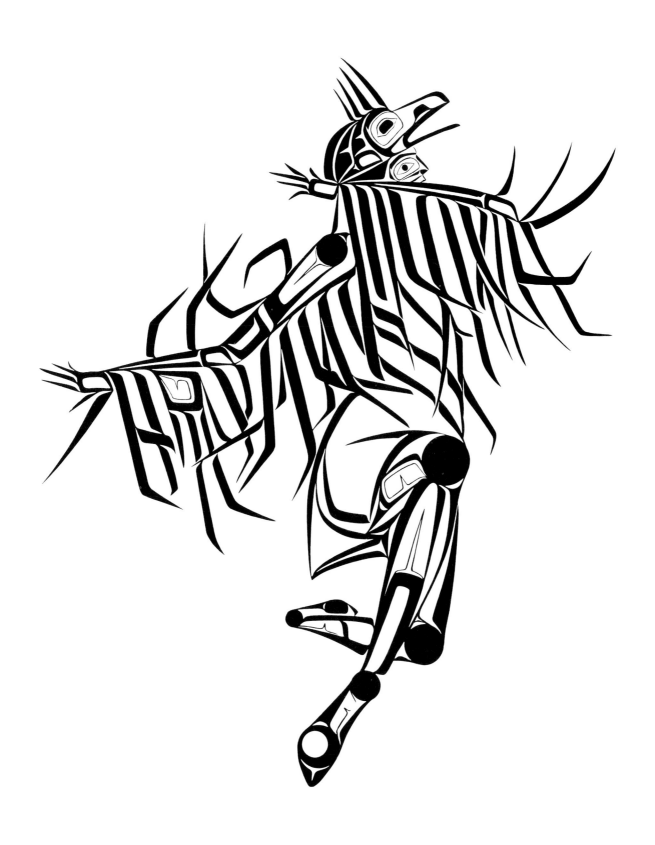

THE GITKSAN DANCE OF THE HUMMINGBIRD FLIGHT / Vernon Stephens, 1975,
edition 126, 66 x 51 cm; black on gold

75

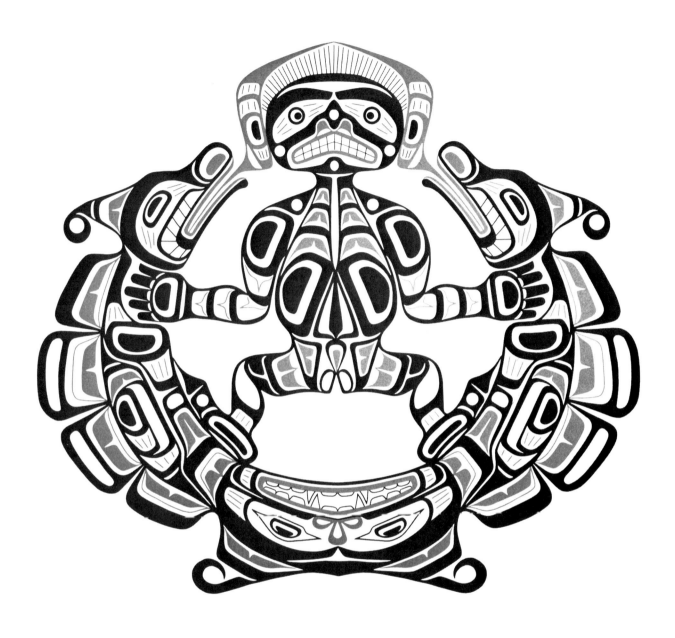

HAMATSA DANCE SCREEN / Richard Hunt, (1977), edition 75, 49 x 65 cm;
black and red on white

The highest ranking Kwakiutl dance society was the Hamatsa or Cannibal society.
Hamatsa initiates, possessed by a man-eating spirit, danced wildly and craved the taste
of human flesh. They were brought back to a state of normalcy by masked dancers.
This print represents in screen form the Hamatsa dancer surrounded by a sisiutl.
Dance screens decorated the houses in which winter ceremonial dances were performed
and shielded dancers during costume changes. Richard Hunt's print was part of the
1977 Guild collection.

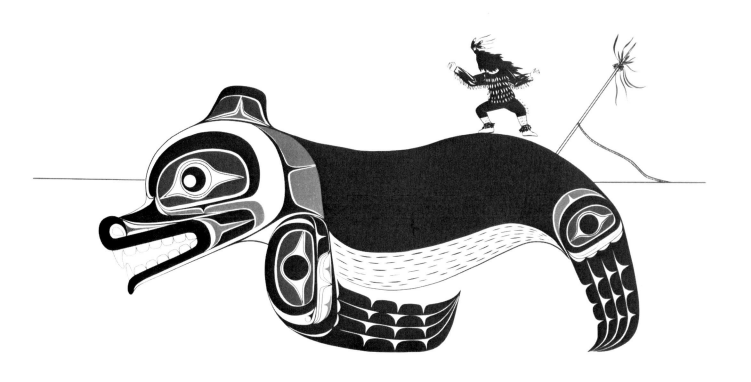

CREATION OF THE SALISH PEOPLE AND THE FIRST MAN / Floyd Joseph,
1978, edition 100, 60 x 102 cm; black, red, and green on beige

A Salish spirit dancer in traditional costume performs atop a Northern style seal in
Floyd Joseph's design.

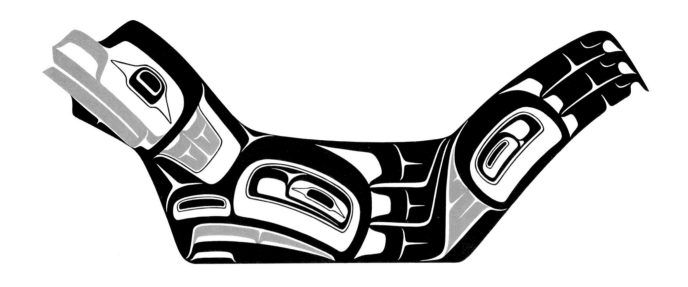

SEAL BOWL / Robert Davidson, *1978, edition 150, 33 x 61 cm; red and black on buff*

A design for an oil dish, in the shape of a seal.

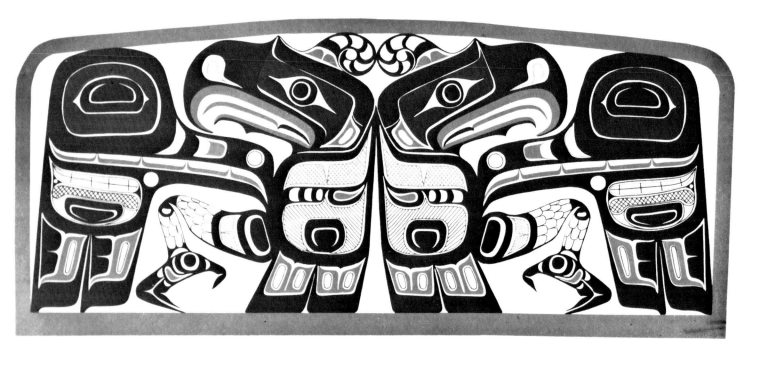

THUNDERBIRD CHIEF SEAT / Tony Hunt, *(1972), edition 125, 42 x 96 cm;*
black, red, and green on white

Traditional chief's seats were carved and painted, or sometimes just painted, on the
back and sides. Usually the design represented one of the chief's crests. This particular
design was done first by the artist on an actual chief's seat.

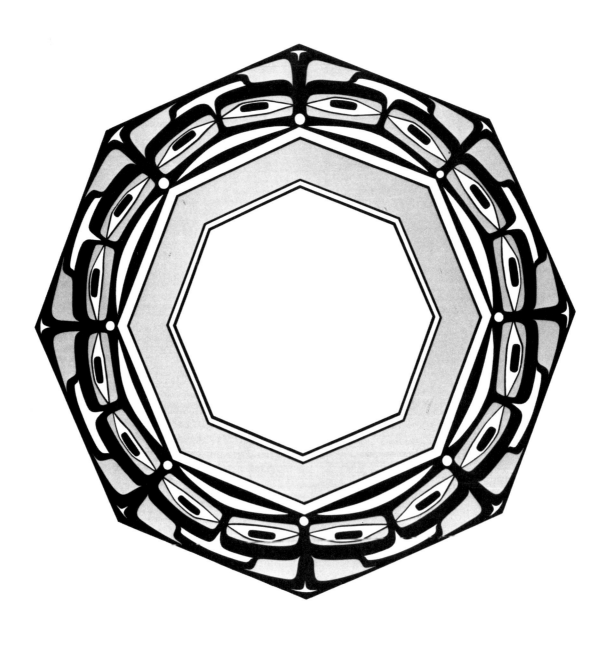

GAMBLER DRUM / Joe David, 1980, edition 222, 56.0 x 49.5 cm;
pale turquoise and black on white

The artist notes that the popular Westcoast gambling game stems from power songs and
the mental ability to move objects at will. "The design here represents crows and blue
stars as seen through a quartz crystal left eye. The faces double for the crows and the
spirits of blue stars." This design was originally done on a drum David has used in
recent ceremonies and is the third in a series of drum designs.

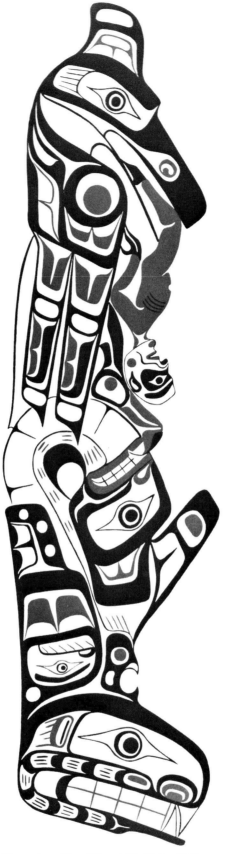

(TOTEM POLE) / Tony Hunt, (1972), edition 125, 62.0 x 16.5 cm; *black and red on white*

An unusual print which represents figures arranged on a totem pole.

QUUT—EAGLE / Robert Davidson, *1977, edition 140, 20 x 20 cm;*
red and black on white

Many contemporary jewelry designs have been translated into silk screen prints. Robert Davidson's eagle derives from the pendant design shown on p. 44, explaining the confinement of the bird to a circular form.

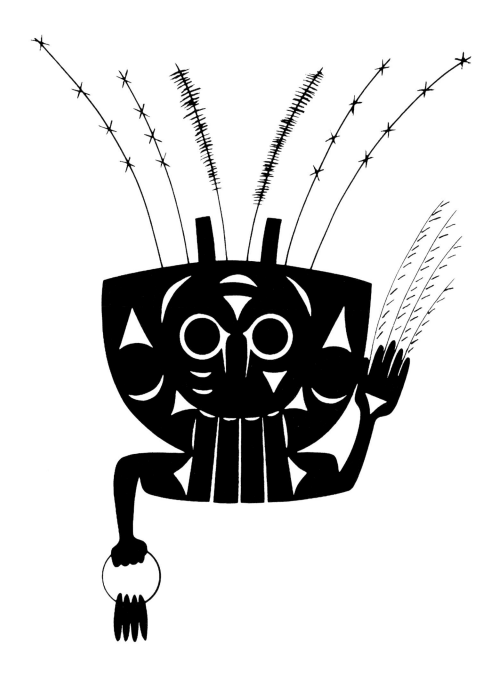

(INVITATION) / Hupquatchew and Art Thompson, *1978, 200 printed, 17.0 x 29.5 cm;*
black on white

A masked Salish dancer with shell rattle decorates the front of this potlatch invitation
card designed by two Westcoast artists. Though many artists have exchanged ideas and
designs, formal collaborative efforts in printmaking such as this one are rare.

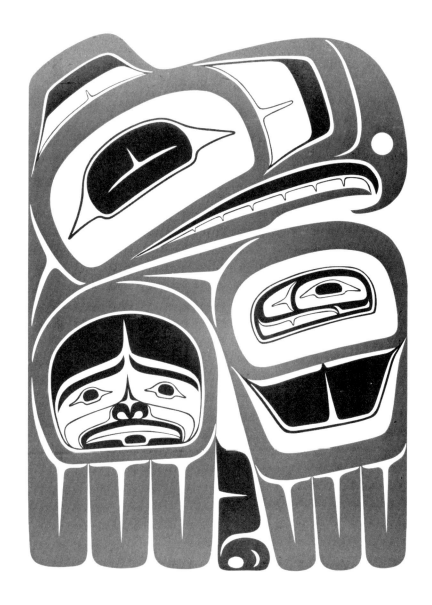

HAIDA HAWK DESIGN / Freda Diesing, *1977, edition 200, 58.5 x 44.5 cm;*
red and black on beige

A sharply recurved beak is typical of hawks in Northwest Coast Indian design. Diesing
used red rather than black for the primary formlines. Haida artist Freda Diesing is one of
several native women who have broken into a once exclusively male art.

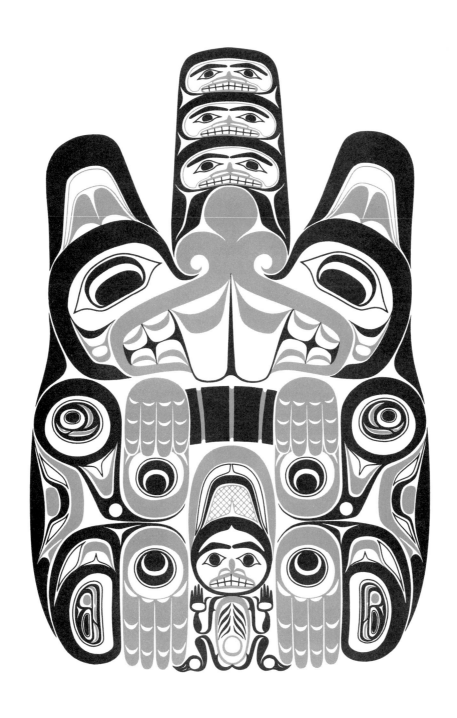

HAIDA BEAVER / Bill Reid, 1978, edition 195, 56 x 76 cm; red and black on buff

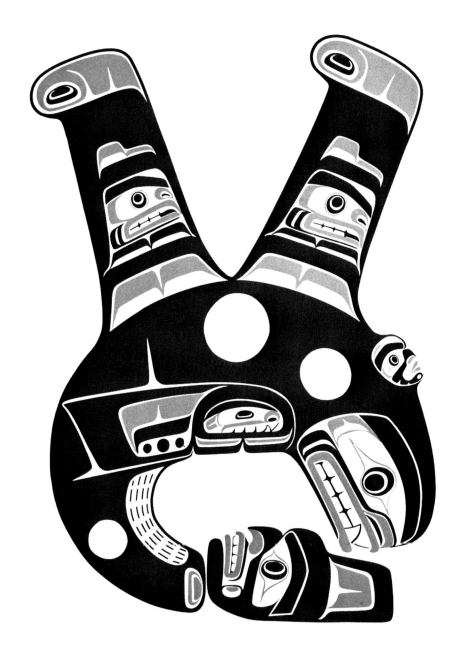

DOUBLE-FINNED KILLER WHALE / Roy Hanuse, *1975, edition 75, 76.0 x 56.5 cm;*
black and red on buff

A typical killer whale with sharp teeth, a blowhole (designated by a face mask), and high
sweeping fins. In this 1977 Guild print, Hanuse has illustrated a mythological two-
finned killer whale.

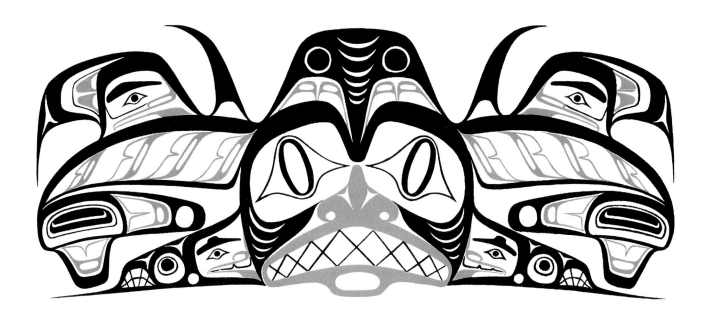

(DOGFISH SHARK) / Robert Davidson, *(1970), 9.5 x 22.5 cm; black and red on white*

The shark's head is shown in full frontal, while the body has been split from the tail and the two profile halves brought forward in the same plane as the head.

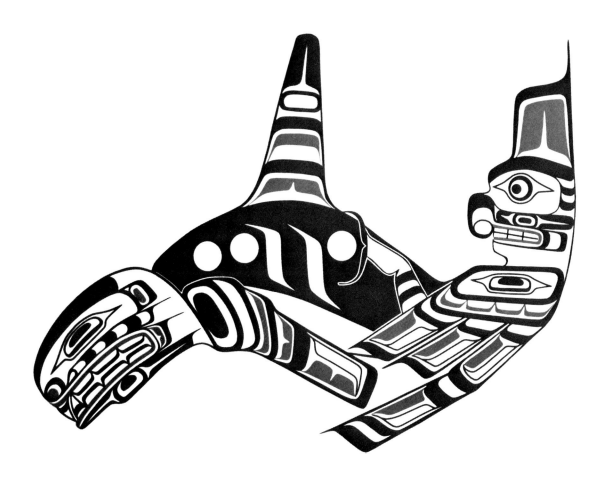

WHALE AND HAWK / Henry Hunt, *1978, edition 125, 37.5 x 56.0 cm;*
black and red on buff

Henry Hunt's design exemplifies the alternation between thick and thin formlines in
Kwakiutl art.

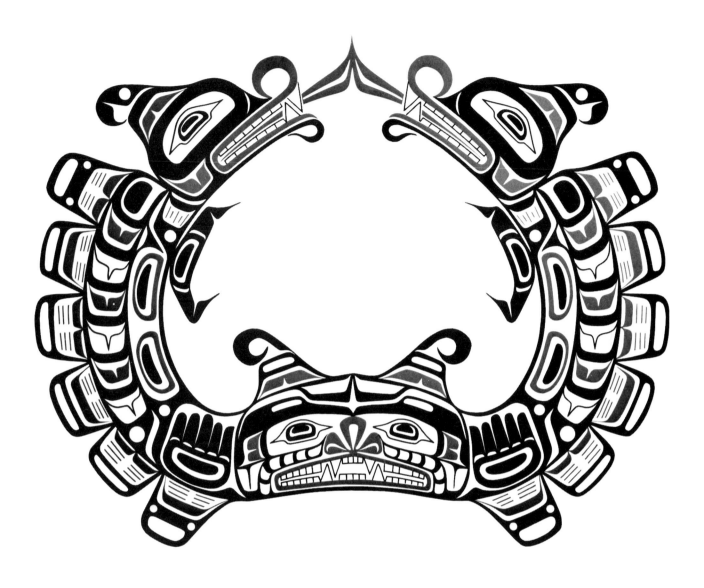

KWAKIUTL SISIUTL / Richard Hunt, *1976, edition 150, 48.5 x 58.5 cm;*
black, yellow, and red on white

The sisiutl, a double-headed sea serpent, was an important creature in Kwakiutl mythol-
ogy. Originally created for Greenpeace, this particular design was also silk screened on
T-shirts. A number of Northwest Coast Indian designs which have been published in
silk screen print form have also been screened on T-shirts, and some designs have been
done exclusively for T-shirts.

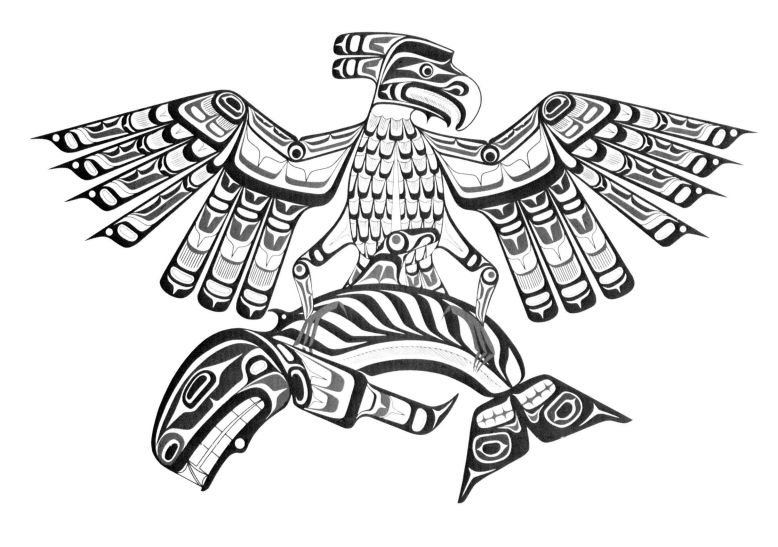

KOLUS AND KILLER WHALE / Tony Hunt, *1977, edition 200, 51.5 x 67.0 cm;*
black, red, and green on beige

Kolus is a mythical Kwakiutl bird who had the power to draw killer whales up from the
ocean waters.

90

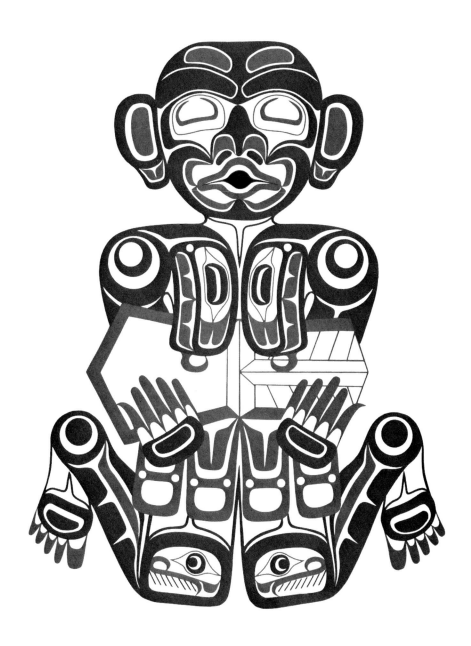

KWA-GUILTH WILD WOMAN HOLDING COPPER / John Livingston, 1974,
edition 132, 56 x 45 cm; black and red on beige

Tsonoqua is a mythical Kwakiutl giantess notorious for stealing children who strayed
from home. Frequently depicted on feast dishes and totem poles, she can be recognized
by her rounded mouth, often sleepy eyes, pendulous breasts, and projecting ears.

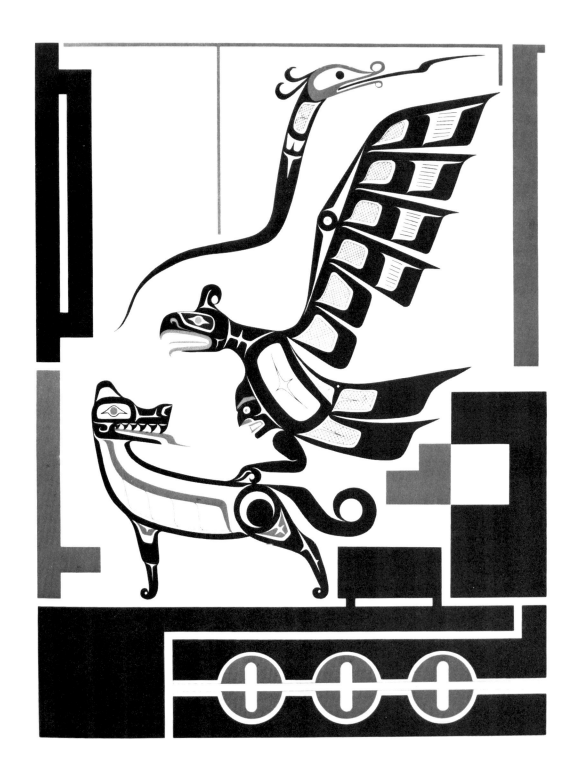

(LIGHTNING SNAKE, THUNDERBIRD AND WOLF) / Hupquatchew, (1973),
edition 100, 69.0 x 53.5 cm; *black, red, and blue on beige*

Thunderbird, lightning snake, and wolf are creatures frequently depicted together in
Westcoast art. Four-way splits (in the body, neck, and wing of the bird), curlicue ele-
ments (on the serpent's head and wolf's tail), and geometric border elements are charac-
teristic of Westcoast style.

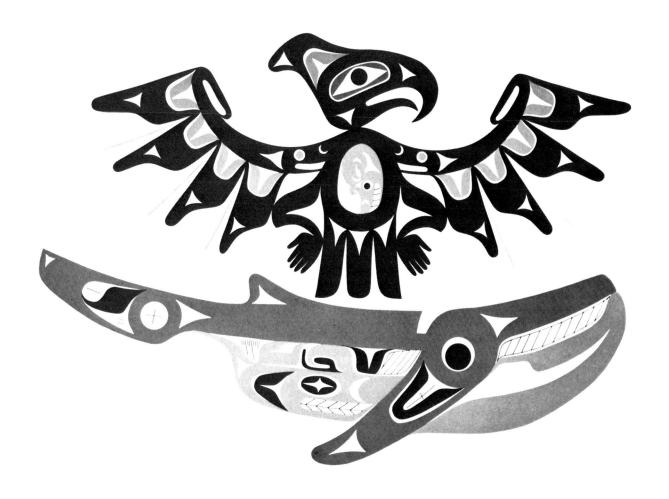

THUNDERBIRD AND WHALE / Art Thompson, *1978, edition 100, 51 x 65 cm;*
black, blue, and red on white

Three of the mythical animals most often appearing in Westcoast art are found in
Thompson's design: whale, thunderbird and, within the thunderbird, lightning snake.

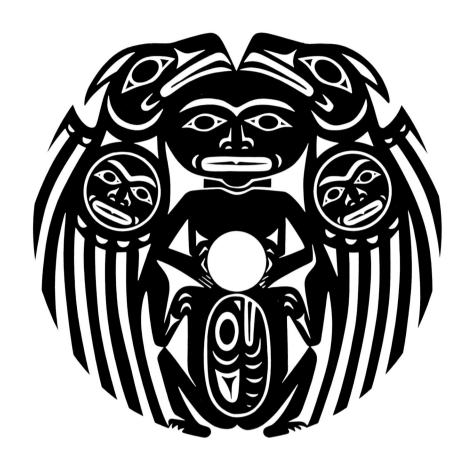

SPINDLE WHORL DESIGN: 'HUMAN WITH THUNDERBIRDS' / Stan Greene, 1979,
edition 100, 50 x 50 cm; brown on white

Salish artist Stan Greene produces designs both in the 'Ksan style in which he was for-
mally trained and in his native Coast Salish art tradition. This print is his rendition of an
old Salish spindle whorl.

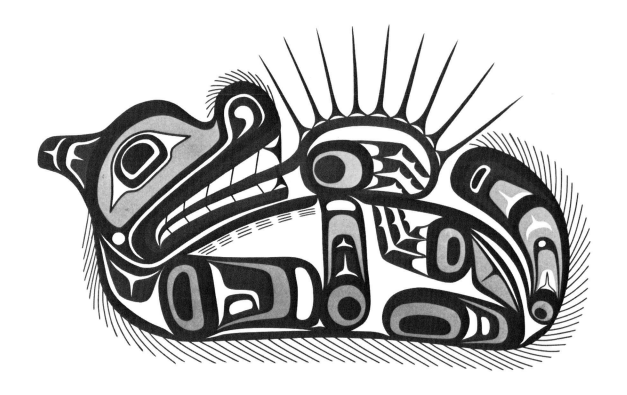

KWA-GULTH SEA OTTER WITH SEA URCHIN / Tony Hunt, *1975, edition 400,*
36 x 53 cm; black, red, and yellow on tan

Hunt's version of sea otter was influenced by an earlier Mungo Martin design.

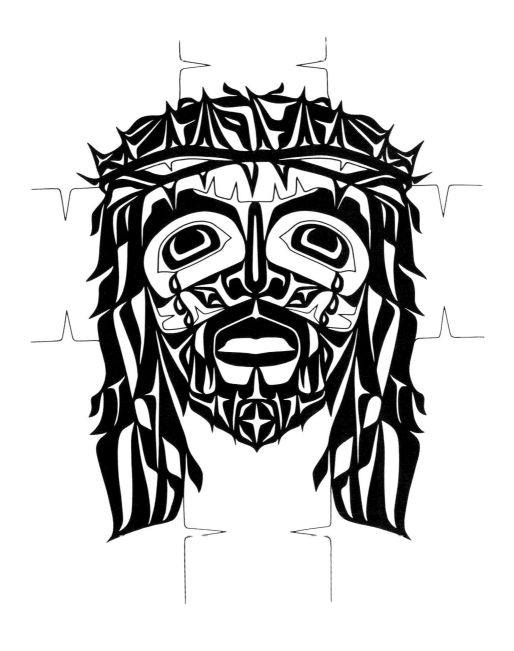

JOHN 15:13, HEBREWS 9:28 / Roy Vickers, *1976, edition unlimited, 51 x 41 cm; black on white*

The artist had this design printed in unlimited numbers and made the prints available at low cost because he wanted to spread the message of Christianity. Several versions of the design, which combined different ink and paper colors, were produced.

96

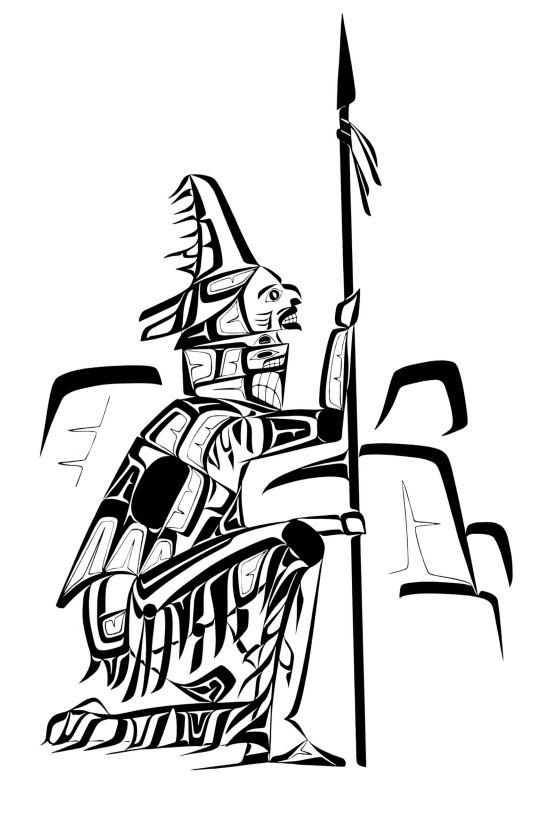

THE GITKSAN WARRIOR, QUEST FOR LAND / Vernon Stephens, *1975,*
edition 130, 66 x 51 cm; black on ivory

Dressed for battle in traditional armor, a warrior looks out over the land.

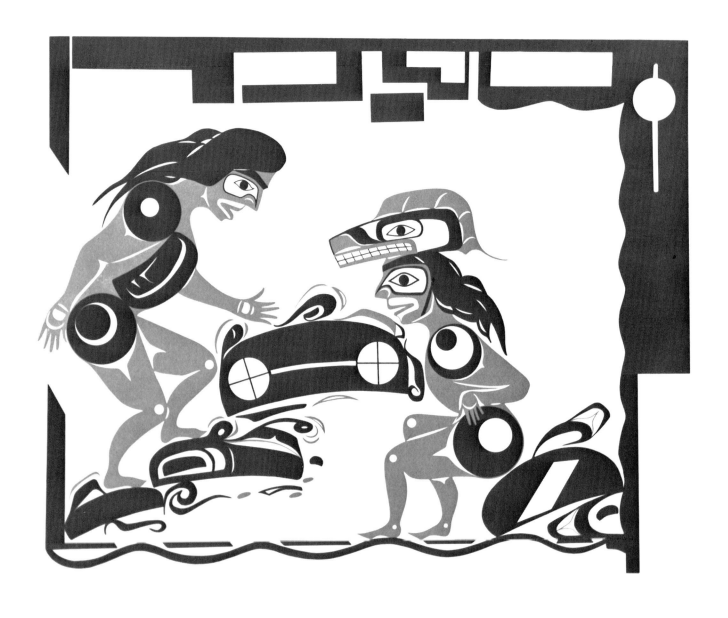

EARTHQUAKE OR 'EARTH QUAKE FOOT' / Tim Paul, *1977, edition 80,*
51 x 66 cm; black and red on white

According to Westcoast legend, a dwarf who dwelled within the mountains would en-
tice the passerby to dance around a large wooden drum. The stranger would eventually
stumble against the drum and succumb to a disease, "earthquake foot," which would
cause the ground to tremble as he walked. Tim Paul was inspired to create this design
after reading an ethnographic account of the Westcoast peoples and discussing the leg-
ends he found therein with Westcoast elders. Specific elements in the design derive
from Paul's study of Westcoast ceremonial objects now housed in museums.

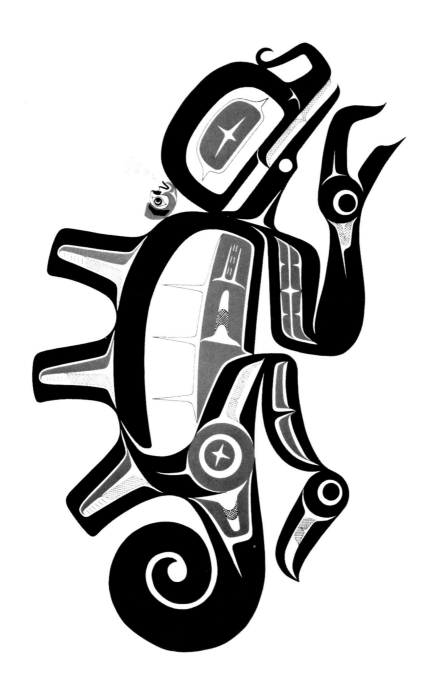

SEA MONSTER / Hupquatchew, *(1974), edition 70, 64.5 x 49.5 cm;*
black and red on gray-beige

According to Westcoast legend, a sea monster which inhabited Barclay Sound on the
west coast of Vancouver Island was so large that a full-sized canoe (forty feet or more in
length) could fit between its claws. When asked why he envisioned the sea monster in
this particular way, given that this creature did not appear in the traditional art, the
artist answered, "How else would a sea monster look?"

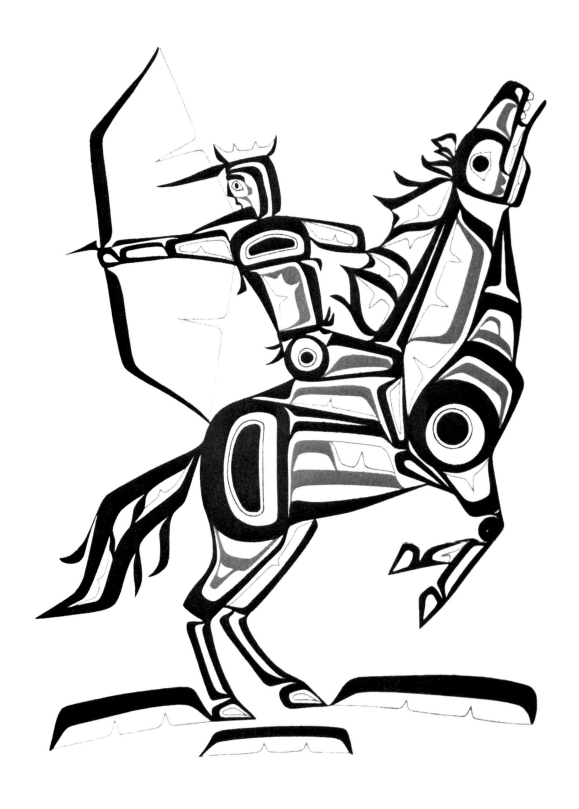

(FIRST HORSEMAN OF THE APOCALYPSE) / Roy Vickers, 1974, edition 200,
46.5 x 34.0 cm; black and red on light beige

MOON / Robert Davidson, *1976, edition 248, 43 x 43 cm; black and blue-green on beige*

One of four moons designed by Haida artist Robert Davidson.

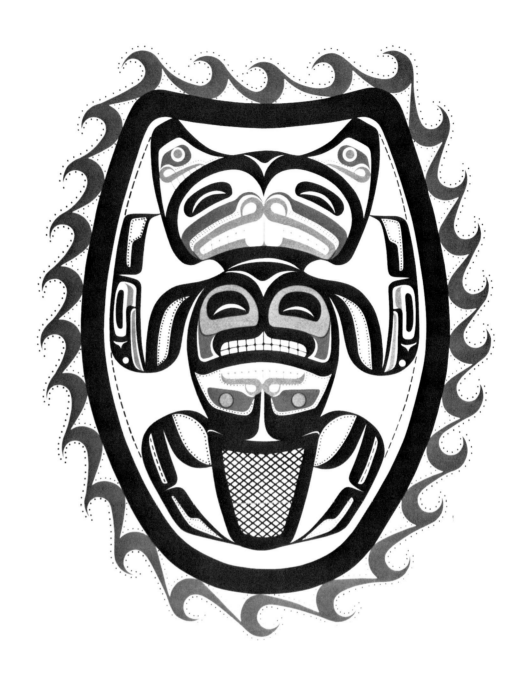

BEAVER IN HOME / Patrick Amos, *1979, edition 600, 66.5 x 51.0 cm;*
black, blue, and red on white

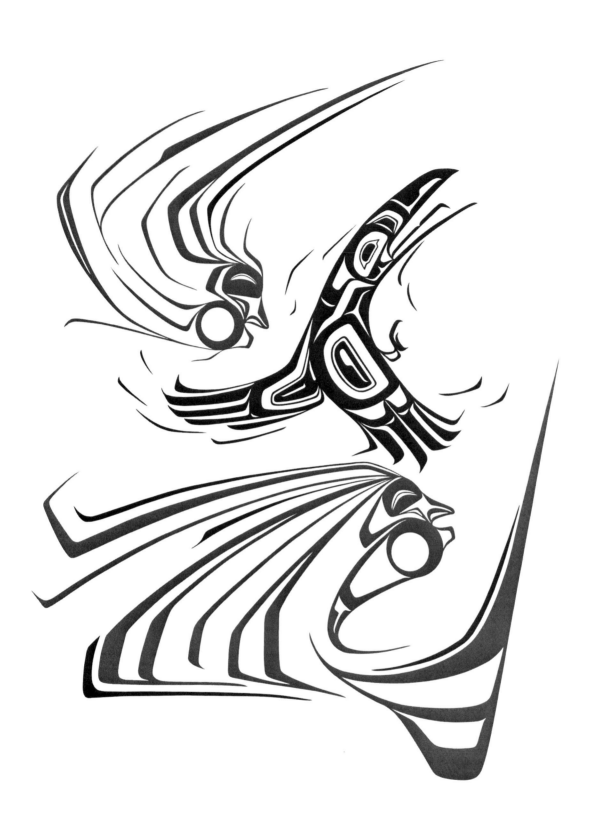

WIND / Ken Mowatt, 1977, edition 50, 76 x 56 cm; red and black on white

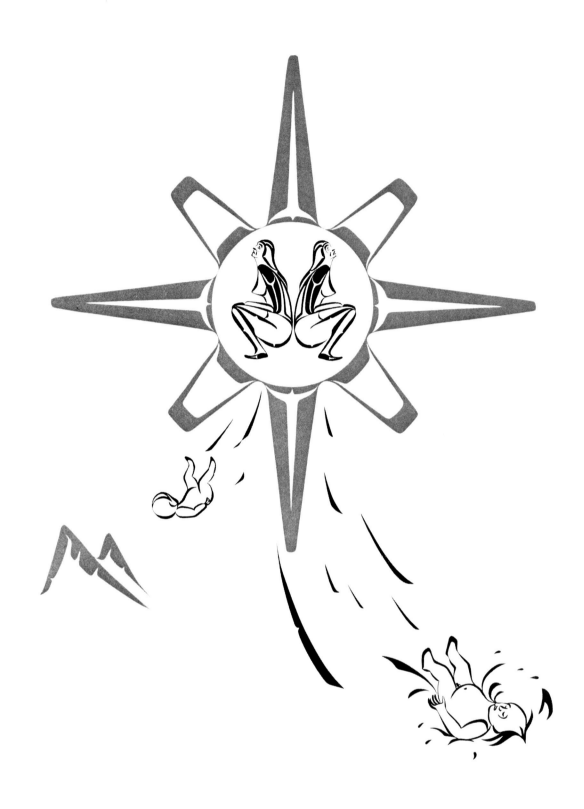

BIRTH OF WEGET / Ken Mowatt, 1975, edition 50, 86.0 x 62.5 cm;
red and black on white

One of a series of designs published in a book of Gitksan legends, Ken Mowatt's print
marks the beginning of the Gitksan culture hero's journey.

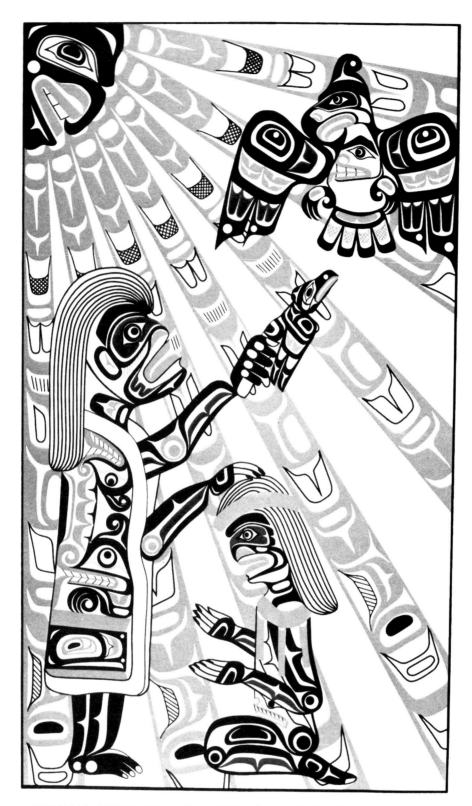

BAPTISMAL MURAL / Tony Hunt, *1976, edition 400, 66 x 43 cm;*
red, black, green, and yellow on tan

The original design was carved and painted on a red cedar panel for the Canadian Catholic Conference Art Collection. John the Baptist is shown as a shaman wearing a Chilkat blanket, while the young chief Christ wears red cedar bark regalia. John holds a raven rattle. The Dove of Peace is depicted as a thunderbird.

HY-ISH-TUP / Art Thompson, *1975, edition 200, 51 x 66 cm;*
black, green, blue, and red on beige

Chitons were a favored native food, and this design was inspired by a chiton-gathering
trip the artist made while living in the city. The thin red lines convey the tension which
characterizes the chiton's attachment to his rock home.

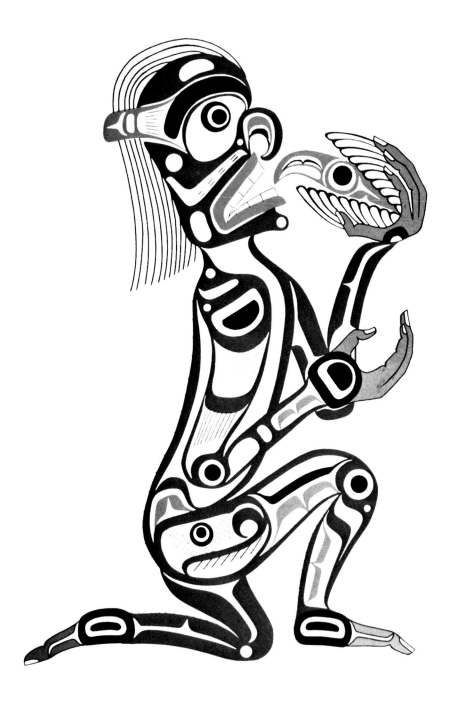

BU-QUIS WITH COCKLE / Tony Hunt, *1975, edition 205, 51 x 33 cm;*
green, black, and red on gray

In Northwest Coast mythology Bu-quis was a woods dweller who was sometimes seen
alone on the beach eating cockles. He was greatly feared because he ate human beings.
Bu-quis appeared in the traditional art only as a mask used in certain dances, but here
Tony Hunt has interpreted him in a flat design.

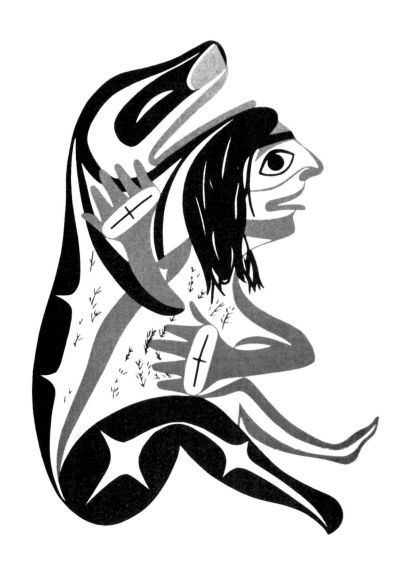

BEAR TRANSFORMING INTO MAN / Tim Paul, *1979, edition 600, 46.5 x 38.0 cm;*
black, red, and green on light brown

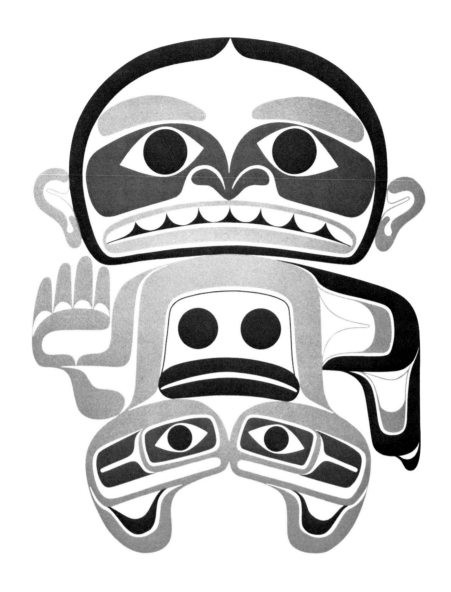

HANU-QWATCHU / Joe David, *1977, edition 75, 57 x 38 cm;*
red, black, and blue on buff

Hanu-qwatchu was once a man but was transformed into a ling cod with a human face.

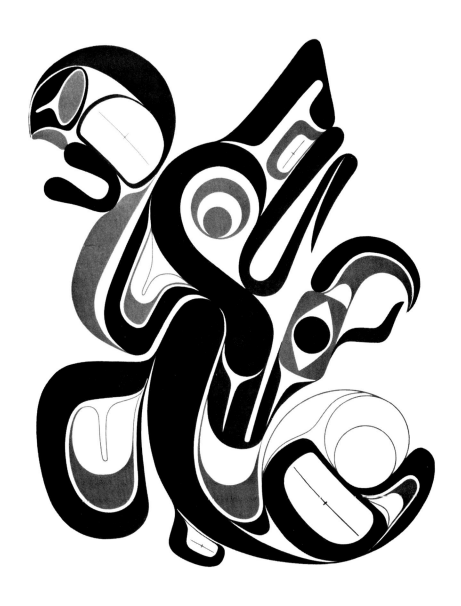

KA-KA-WIN-CHEALTH / Joe David, *1977, edition 75, 57 x 38 cm;*
black, red, and blue on buff

Ka-Ka-win-chealth is a native name of the artist and also means "supernatural white
wolf transforming into killer whale." A Westcoast legend tells how this transformation
took place and why killer whales are half-black and half-white and, like wolves, travel
in groups. David has employed his fluid or liquid formline in this design.

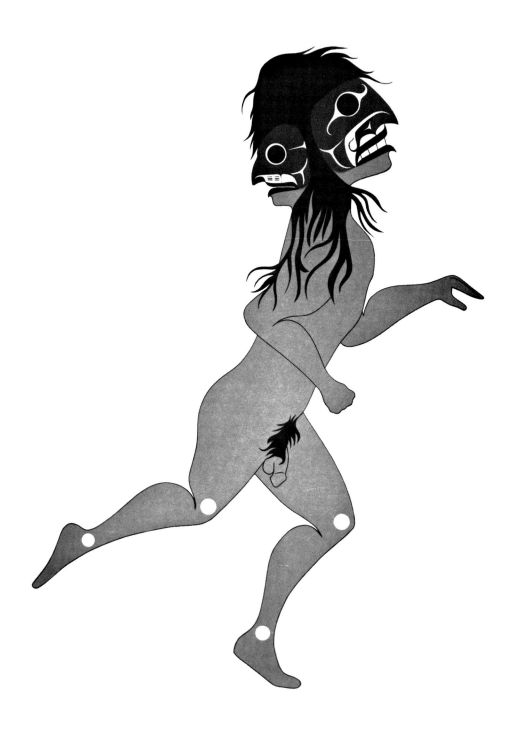

KOO-KWATH-PA-THLA / Art Thompson, *1975, edition 200, 58.5 x 44.5 cm;*
red, blue, and black on beige

Two-faced boy was a mythological Westcoast character of great strength who easily
outwrestled his adversaries. The sexual features of the figure are more graphically de-
picted than in most Northwest Coast art.

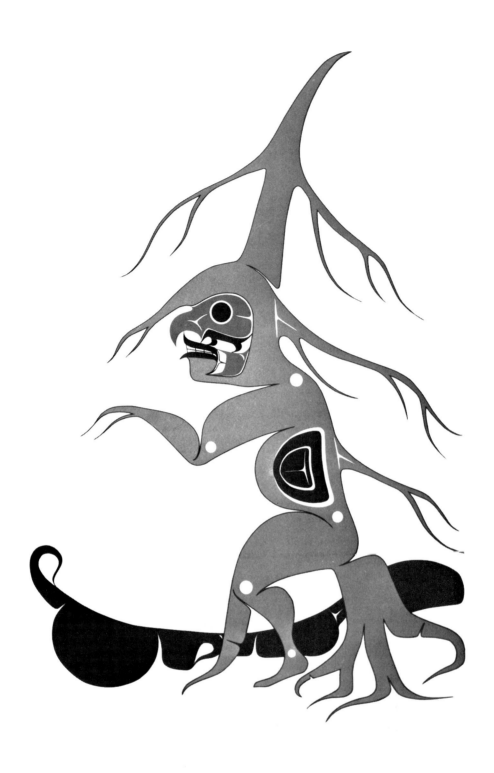

UTHL-MUC-KO (YELLOW-CEDAR-MAN) / Art Thompson, *1976, edition 100,
66.5 x 51.0 cm; red, black, and green on white*

Thompson portrays the instant of metamorphosis in one episode of a long Westcoast
myth.

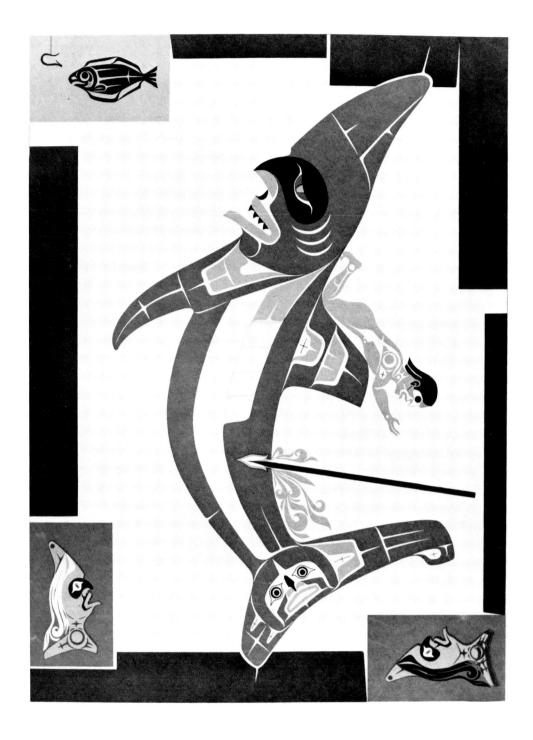

KWATYAHT AND MAMASIYIK / Hupquatchew, *1977, edition 75, 94 x 63 cm; blue, black, and red on brownish-green*

Presented in the 1977 Guild collection, this print depicts a story in which the culture hero, Kwatyaht, attempts to slay a giant shark that has been stealing his halibut. The shark is really a woman who offers her two human-shark daughters to Kwatyaht in marriage. Shown in the print are the attempted slaying, the halibut, and the two daughters.

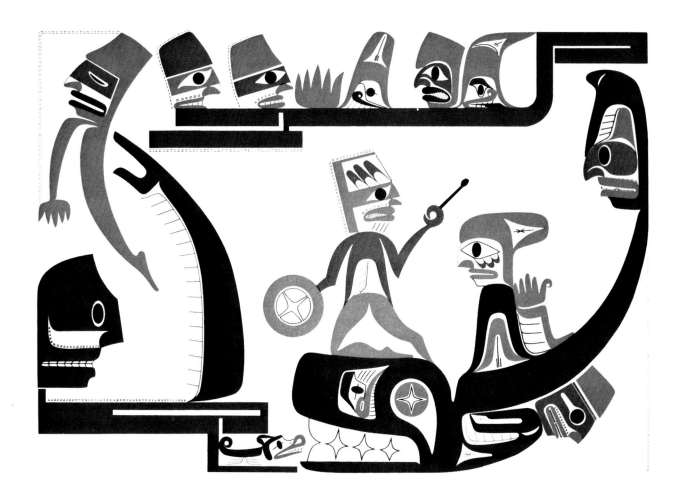

CLO-OOSE VISION / Art Thompson, *1978, edition 125, 50 x 64 cm;*
black, red, blue, and green on buff

The idea for this print came from a dream the artist had prior to a memorial potlatch
given in honor of his father. The design illustrates the narrative of the dream.

114

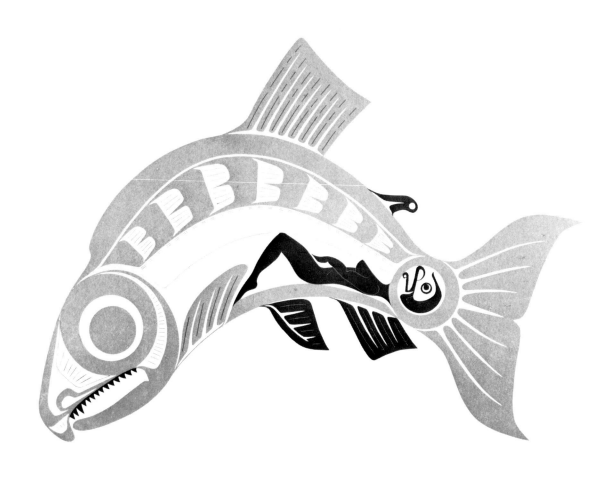

SATSUP DESIGN / Hupquatchew, *(1973), edition 100, 43.0 x 57.5 cm;*
red and black on beige

115

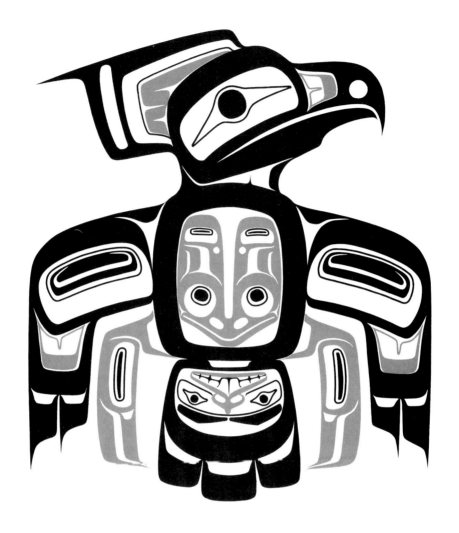

(EAGLE) / Robert Davidson, 1976, 500 printed, 40.5 x 35.5 cm; black and red on beige

A print made exclusively for distribution at the potlatch marking the installation of the Masset Haida town chief. The print depicts eagle and frog, two of the chief's crests.

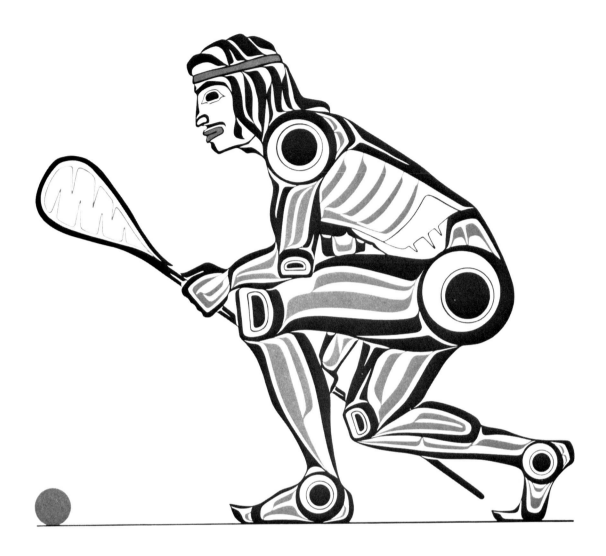

LACROSSE PLAYER / Roy Vickers, 1978, edition 200, 38 x 38 cm;
black and red on white

Vickers' print was created to commemorate the 1978 Commonwealth Games
held in Edmonton.

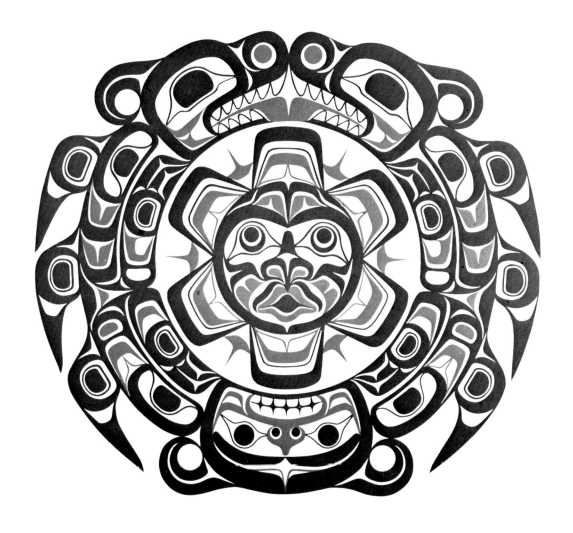

SI-SI-UTL AND TLI-SLI-GI-LA / Beau Dick, *1976, edition 200, 58.5 x 58.5 cm; black and red on beige*

Using Northern formline and formline elements, Beau Dick has depicted a Kwakiutl sisiutl and sun. The mouth, nose, eyes and cheek designs on the sun are Kwakiutl in style, while the remaining elements are Northern.

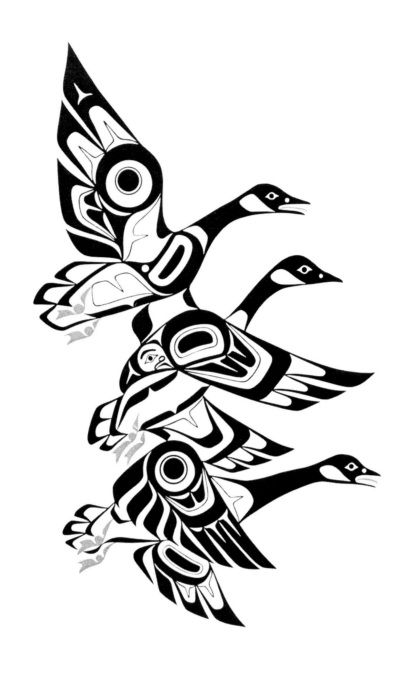

GEESE / Glen Rabena, *1978, edition 199, 51.0 x 35.5 cm; black and red on white*

Influenced by the 'Ksan style, Glen Rabena produces naturalistic designs which appeal to many people outside Northwest Coast art circles.

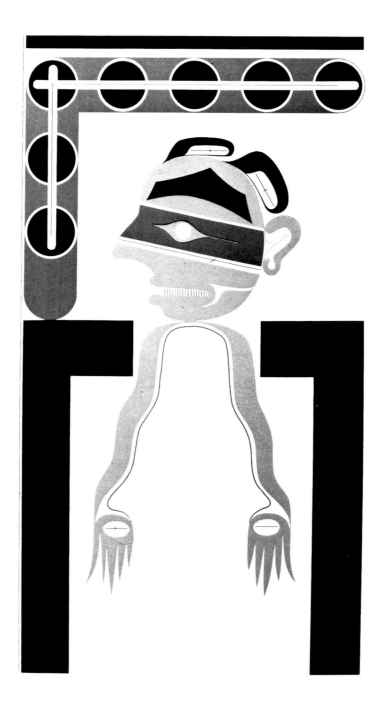

EATS-QWIN / Joe David, *1977, edition 75, 57 x 38 cm; black, blue, and red on buff*

Eats-qwin is a mouse who inhabits the island where the artist lives. The geometric forms outline the mouse's earthly home and the sky above. In this design, Joe David has used thin lines to accentuate various portions of the mouse's anatomy.

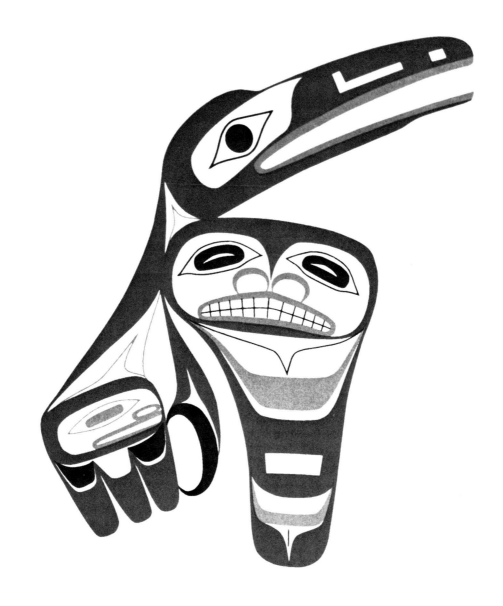

BLUE RAVEN / Tim Paul, *1979, edition 600, 38.0 x 35.5 cm; blue, red, and black on buff*

A mythological blue raven brought great luck to Westcoast hunters and fishermen who caught a glimpse of him. Tim Paul's design is noteworthy for its use of geometric shapes as internal design features.

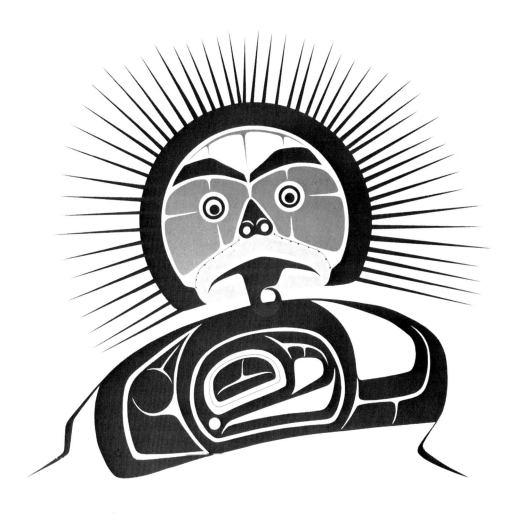

SEA URCHIN / Art Thompson, *1974, edition 200, 44.5 x 58.5 cm;*
black, purple, yellow, red, and pink on beige

The sea urchin was rarely depicted in the traditional art. In his version, Art Thompson
has used naturalistic colors and has anchored the sea urchin to a rock created in the
form of a salmon-trout head. The inspiration for the spines of the shellfish came from
the unruly hair of the artist's baby daughter.

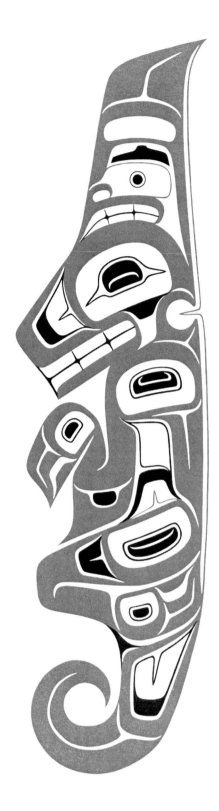

SEA WOLF / Donald Yeomans, *1978, edition 195, 56 x 25 cm; red and black on white*

A mythical Haida creature—part wolf, part killer whale—is depicted in a vertical design by Don Yeomans. Normally secondary lines are contained within the primary formline, but here a thin secondary line runs the length of sea wolf's back, outside the primary formline.

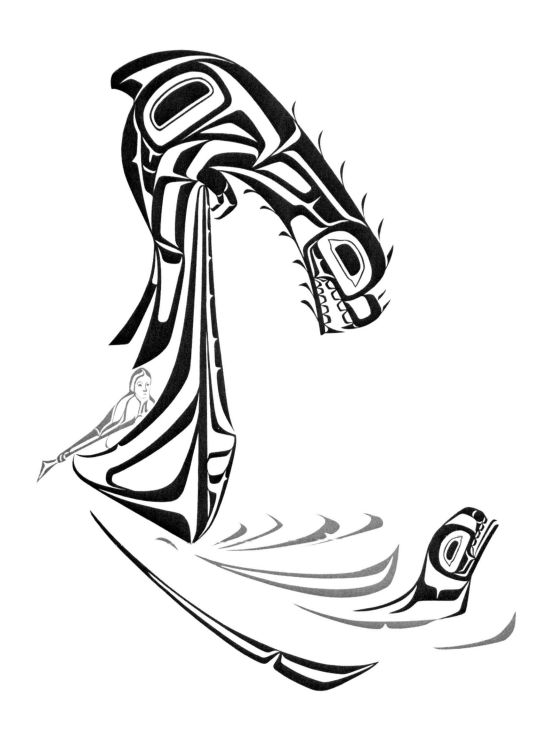

WEGET AND HALA-LAA / Ken Mowatt, *1976, edition 50, 75.5 x 56.5 cm;*
black and red on white

One of a series of designs published in a book of Gitksan myths, this print depicts the
Hala-laa, a spirit who dived for seals, poised on the prow of Weget's canoe. Note the
three-dimensional appearance of the canoe.

RAINBOW / Art Thompson, *1975, edition 112, 51.0 x 66.5 cm;*
red, green, blue, and yellow on white

Genitalia represented by a four-way split and breasts fashioned from U-forms and
ovoids characterize rainbow as a woman; her long, flowing tresses in naturalistic colors
form the rainbow itself.

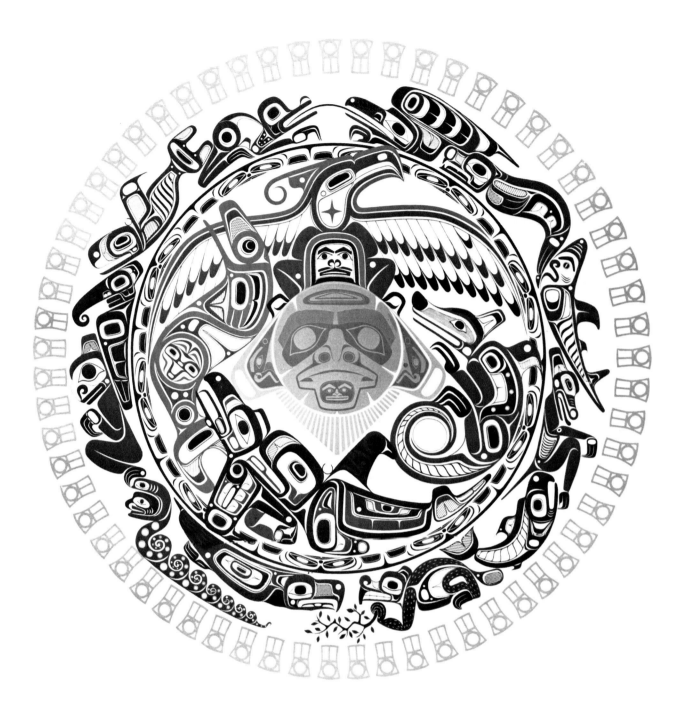

POWER OF THE SHINING HEAVENS / Barry Herem, 1978, edition 100, 71 x 71 cm;
black, dark red, light red, blue, copper, silver, and gold on gray

The title of Barry Herem's print refers to a Haida spirit which gave power to all other
things. This power is depicted in gold at the center of the design. Immediately surround-
ing "Power of the Shining Heavens" are mythological figures important to different
Northwest Coast tribes. These creatures are separated from earthbound crest animals by
a ring of silver elongate faces. The outermost ring of 62 coppers represents the wind.
"Power of the Shining Heavens" was commissioned by Alaska Airlines as a poster
design.

REFLECTIONS / Robert Davidson, *1977, edition 75, 57 x 32 cm; black and red on buff*

In this 1977 Guild print, Robert Davidson achieved a textured effect by overprinting the black in the center of the design.

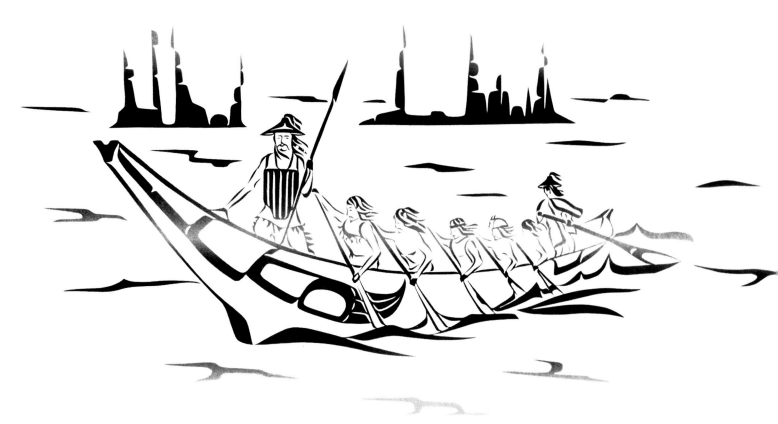

RAIDERS / Vernon Stephens, *1978, edition 70, 57 x 76 cm; red, blue, and black on buff*

A war party departing by canoe on a raiding expedition is shown in Stephens' print from the first 'Ksan graphics collection. The production of this print represents the first time in Northwest Coast graphics that three separate colors were simultaneously screened. The process yielded an edition of 70 unique prints.

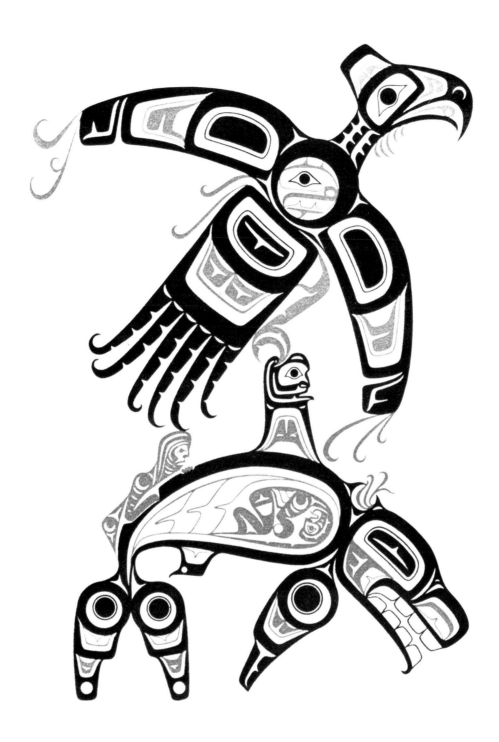

NE-WALPSU: THE PEOPLE OF MY HOUSE / Art Sterritt, *1978, edition 100,*
76 x 56 cm; black and red on buff

In this print from the 1978 'Ksan collection, Art Sterritt depicts his family and their
crests. The eagle represents the artist, the killer whale his wife. In Gitksan culture chil-
dren take their mother's crest. Thus, here the artist's daughter clings to the back of the
killer whale, the son forms the dorsal fin, and the unborn daughter is shown within the
body of the killer whale.

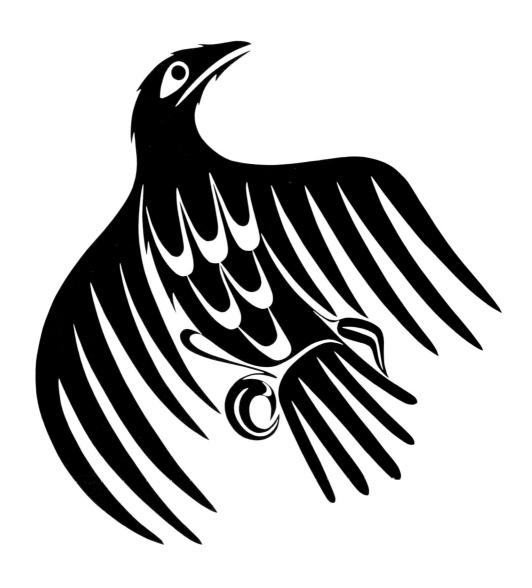

KA-IN / Joe David, 1978, edition 75, 38.0 x 35.5 cm; black on buff

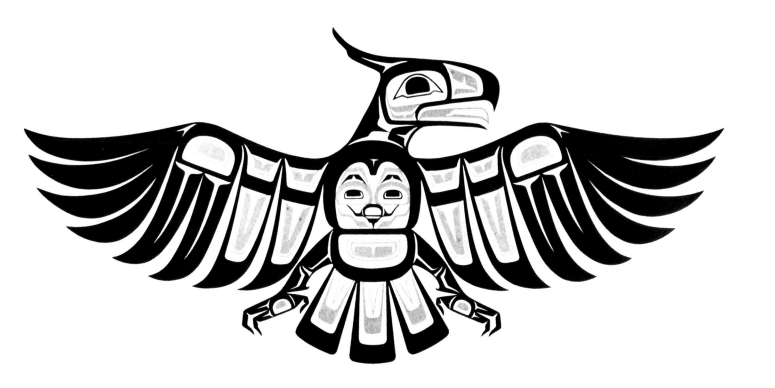

THUNDERBIRD / Clarence Wells, 1979, edition 150, 46 x 76 cm; black and red on beige

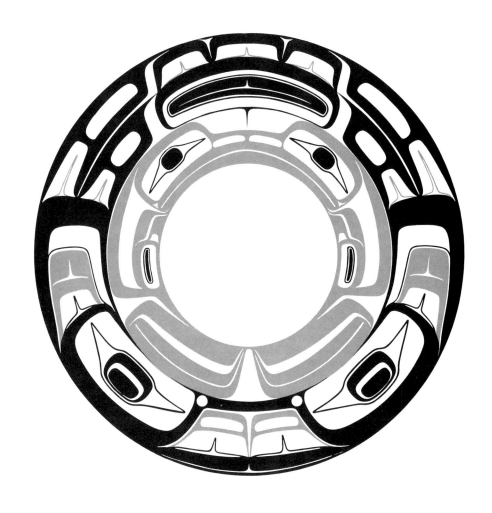

EAGLE / Robert Davidson, 1979, edition 100, 53.5 x 53.5 cm; black and red on buff

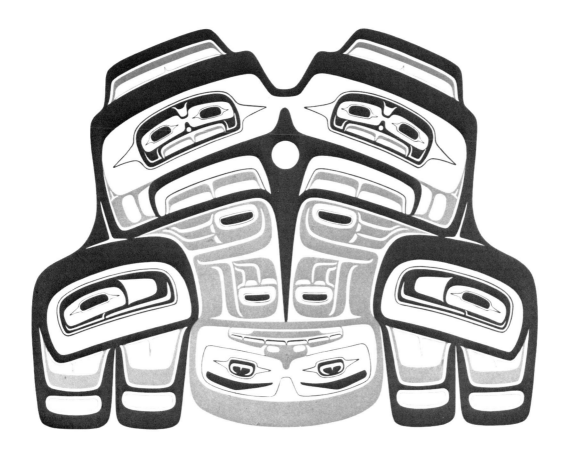

RAVEN WITH BROKEN BEAK / Reg Davidson, *1979, edition 229, 37.0 x 39.5 cm;*
black and red on white

The trickster Raven once tried to fool a blind halibut fisherman by tugging at his fishing
line. The exasperated fisherman yanked on the line, breaking off Raven's beak.

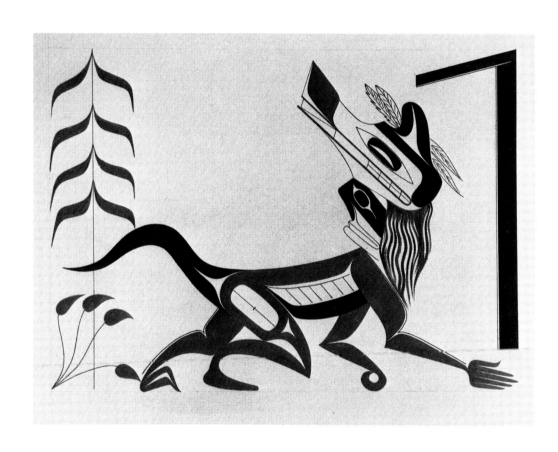

"Crawling Wolf Dancer" by Art Thompson, original painting.

Appendix 1: The Printing of a Northwest Coast Indian Serigraph

"Crawling Wolf Dancer," an original four-color painting by Art Thompson, is being made into a serigraph at Open Pacific Graphics in Victoria. Screened onto Arches Cover Buff, the edition of sixty prints is being privately distributed by Open Pacific Graphics.

According to a Westcoast legend, an ancestor wandered into the house of wolves. The wolf spirits, taking pity on the human intruder, taught him songs and dances which he demonstrated to his people upon his return home. The Wolf ceremony, or Klukwana, held by the Westcoast people, includes reenactment of the legend by a dancer attired in wolf headdress.

1. The printer tapes a sheet of amberlith, a two-ply, lacquer stencil-making film, to the original. With a sharp cutting knife, he traces by hand all design elements in a single color, beginning with the darkest color, which will be printed last.

2. The knife cuts through the hard lacquer film layer but not the clear plastic backing. Nondesign portions of the amberlith are peeled away, leaving only the darkest design elements covered by the film. A new sheet of amberlith is used for each design color. Thompson's design required four sheets: one each for black, brown, red, and green. After all the positives have been cut, the artist may check the results with the printer.

3. Very fine lines are cut with a double line cutter or, alternatively, inked onto the clear plastic backing with India ink. Cutting, which must be very precise, is facilitated by the use of jewelers' magnifying glasses.

4. There are several methods of making stencils; that currently in use at Open Pacific Graphics is the most widely accepted. Each amberlith positive is contact printed onto a sheet of photo-stencil film, a light-sensitive gelatin emulsion on a clear plastic backing. In the stencil-making process, light passes through the clear plastic backing of the amberlith positives, but is prevented from passing through the orange lacquer design areas. Light hardens the exposed portions of the gelatin emulsion; unexposed areas are then washed away, leaving a negative image. While still wet, the gelatin stencil is blotted into a silk mesh screen stretched over a printing frame. When the stencil is dry, the plastic backing is peeled off and the screen is ready for printing. A separate screen is made for each ink color.

5. Paper is positioned beneath the screen, and ink is forced through the silk with a squeegee to produce the image. The paper is then set aside in a rack to dry, and succeeding papers are printed in the same manner. The ink must be completely dry before the next color can be printed. Careful attention must be paid to registering the colors accurately; that is, each time the paper is positioned under the screen it must be done so that the different colored portions of the design meet in exactly the way the artist intended.

6. When all the print runs are finished, the artist checks over each print and accepts those that meet his standards. These are signed, titled, and numbered. Then stencils are washed out of the screens and, once the artist accepts the edition, the positives are usually destroyed.

Tracing design elements on amberlith film.

Fine lines are made with a double line cutter.

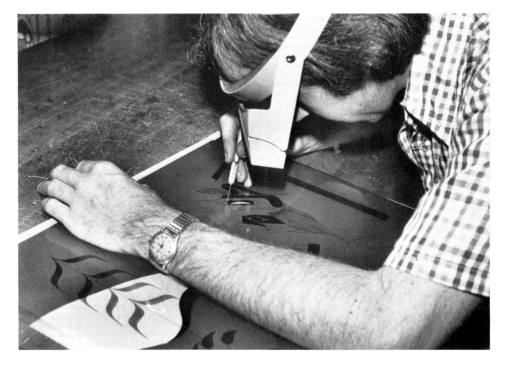

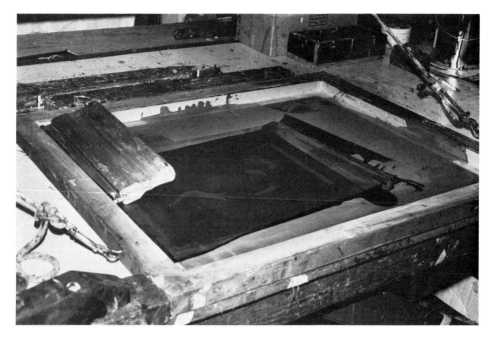

The stencil for black ink adhered to the screen.

The ink is forced into the screen with a squeegee.

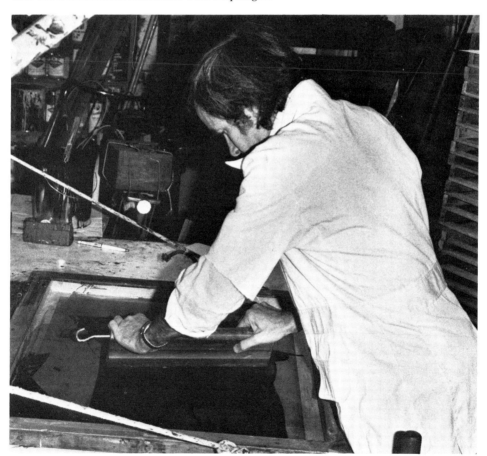

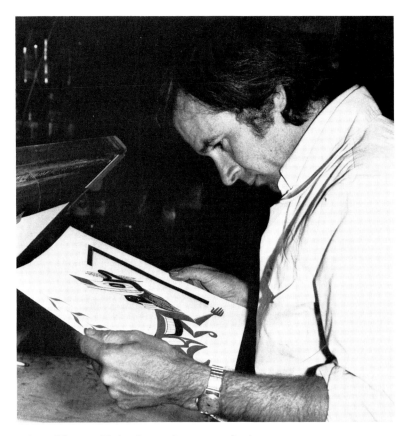

Printer Vincent Rickard examines a proof print.

Art Thompson signs, titles, and numbers his prints.

Appendix 2: Northwest Coast Indian Artists Working in Serigraphy

As of mid-1980, the following artists are known to have created designs for reproduction as silk screen prints. This list was compiled from all available sources, but may not be definitive; we apologize to any artist whose name we have inadvertently omitted. Tribal affiliations were determined from the information artists included when signing prints and through reference to the *B.C. Native Artisan File* compiled by the Vancouver Centennial Museum. However, it should be noted that Northwest Coast Indian artists do not always design in the style of their ethnic group of origin.

Carrier (Athapaskan-speaking peoples influenced by Gitksan culture)

Mary Duncan
Alfred Joseph
Walter Joseph
Larry Rosso
Robert Sebastian
Ron Sebastian

Coast Salish

Charles Elliot
Stan Greene
Francis Horne
Jimmy Johnny
Floyd Joseph
Doug LaFortune
Marvin Oliver
Spencer Point

Haida

Richard Atkins
R. C. Cook
Claude Davidson
Reg Davidson
Robert Davidson
Freda Diesing
Pat Dixon
Sharon Hitchcock
Gerry Marks
Bill Reid
Dwayne Simeon
Paul White, Jr.
Francis Williams
Doug Wilson
Donald Yeomans

Heiltsuk (Bella Bella)

David Gladstone
Gordon Gladstone
Michael Hall
Robert Hall
Lyle Wilson

Kwakiutl

Bruce Alfred
Harold Alfred
Doug Cranmer
Amos Dawson
Beau Dick
Roy Hanuse
Mark Henderson
Calvin Hunt
George Hunt, Jr.
Henry Hunt
Noreen Hunt
Richard Hunt
Stan Hunt
Tony Hunt
Dennis Matilipi
Victor Newman

Kwakiutl

Alvin Scow
Jerry Smith
Russell Smith (Awasatlas)
Henry Speck
Richard Sumner
Lloyd Wadhams
Ray Wadhams
Bill Wilson

Tlingit	Tsimshian (including Coast Tsimshian, Gitksan, and Nishga)	Westcoast
Nathan Jackson		Patrick Amos
Dempsey Bob	Art Bolton	Frank Charlie
	Danny Dennis	(Kwyatseek-Tchuss-Miyuh)
	Saxs Dudoward	Ben David
	Eric Gray	George David
	Henry Green	Joe David
	Walter Harris	Harold George
	Chuck Heit	Hupquatchew (Ron Hamilton)
	Jack Hudson	Simon Lucas
	Robert Jackson	Tim Paul
	Phil Janzé	Terrence Sabbas
	Alice Jeffries	Art Thompson
	Sandy Miller	Richard Watts
	Ken Mowatt	Harvey Williams
	Earl Muldoe	
	Samuel Nelson	
	Vernon Stephens	
	Art Sterritt (Miyanxa)	
	Neil Sterritt	
	Norman Tait	
	Roy Vickers	
	Clarence Wells	
	Ray Wesley	
	Gordon Wilson	
	Tillie Wilson	
	Glen Wood	

Reproductions

The designs of a number of Northwest Coast Indian artists have been reproduced as silk screen prints though the original work was in another medium. For example, designs from old painted boxes and carved argillite platters are now available in the form of silk screen prints. Most of these artists are not now known by name, but two whose designs have been screened are Charles Edenshaw (Haida) and Tom Price (Haida).

Non-Northwest Coast Indians and non-Indians

A considerable number of silk screen print editions of Northwest Coast Indian designs have been done by non-Indians or by Indians from other than Northwest Coast groups. The identification of individuals as "Indian" or "non-Indian" involves exceedingly complex legal and emotional issues. Correspondingly, mixed emotions surround the creation of Northwest Coast Indian designs for commercial purposes by non-Northwest Coast Indian artists. We agree with one artist interviewed who feels that Northwest Coast art has so much inherent power, integrity, and beauty that, in terms of aesthetics at least, squabbles over the ethnic identity of its creators are unimportant. For that reason, and because the collector will encounter silk screen designs by non-Indians and non-Northwest Coast Indians, the names of those known to have worked in serigraphy are listed below.

Gene Brabant	Shirl Hall (Yukmé)	Phillip Oppenheim
Harry Calkins	Barry Herem	Duane Pasco
Cliff Delorme	Peter Hilgeford	Glen Rabena
Jean Cohn Ferrier	John Livingston	Tom Speer
Jim Gilbert	Don McCleary	Alex Williams
Charles Gruel	G.A. Mintz	Robin Wright

Some Useful Definitions

About Editions

Edition. An edition is the total number of prints run, and not destroyed, of a particular design. The size of an edition is set by the artist, sometimes in conjunction with a publisher (a business firm that distributes prints for an artist). An edition may be unlimited, that is, repeated runs of the design may be made if it proves popular; in a limited edition a finite number of prints are run. Northwest Coast Indian silk screen limited edition prints have ranged in edition numbers from 7 to 1000. Beyond the numbered prints in an edition, there frequently are additional copies including artist's proofs, a printer's proof, and remarque copies.

Numbering. Limited edition Northwest Coast Indian silk screen prints are numbered with what appears to be a fraction (e.g., 17/100). The denominator (100) represents the total run of the edition, not counting artist's proofs, etc., and the numerator (17) indicates the number of the particular print being viewed. The numbering of prints in this fashion has become established custom, based on the assumption of many buyers that the lower numbered prints are somehow better. However, silk screen prints are rarely kept in the order in which they were printed, and thus 1/100 is quite likely not the first print to come off the screen. More importantly, silk screen stencils do not wear down, so the quality of printing does not decrease as more prints are run. Print quality can vary independently of any numbering system because of poor registration, dust spots, etc., and the buyer should carefully examine every print, whatever its number. Sometimes an edition will be on two or more different types of paper, or the image will be printed in different ink colors on some prints. Such split editions have traditionally been numbered as a single edition; for example numbers 1 to 50 on white paper and 51 to 100 on beige paper.

Artist's Proofs. Customarily the artist retains a certain percentage of the edition, outside of the numbered prints, for personal use. Some artists hold their proofs as insurance against lean times, while others give them to friends. The presently accepted limit for artist's proofs is 10 percent of the total edition; for an edition of 200 there would be not more than an additional 20 artist's proofs. These are signed by the artist as artist's proofs and, sometimes, numbered in Roman numerals (e.g., II/IX).

 Northwest Coast Indian artists have not always limited artist's proofs to 10 percent of the edition, particularly in the case of editions run in the early days of working in this medium. Additionally, some Northwest Coast Indian artists immediately sell their proofs.

Printer's proof. If a printmaker prints an edition, the artist traditionally gives him or her one signed but not numbered print.

Remarque prints. On some editions, additional copies, up to 10 percent of the edition total, are set aside as remarque or "French" copies. The artist signs these prints and adds a small unique pencil drawing beside the signature. Remarque prints usually sell for considerably more than regular edition copies.

141

Series. Sometimes an artist produces several editions, each a different design, relating to the same subject. For example, Art Thompson's "Seafood series" consisted of five different designs representing cod, halibut, clam, mussel, and barnacle.

Signing of prints. Traditionally, prints are signed by the artist in pencil. Most artists also include a title and the year of publication. Unlimited prints are sometimes not signed.

Printed initials. If the artist's initials appear silk screened on the print (in addition to a pencil signature), then the artist did the printmaking and/or cut the stencils.

Embossing stamps. Sometimes also called "chop marks," embossing stamps are logos placed on limited edition prints by either the printmaker or the publisher. Usually found on the lower left or right hand corner of the print, the embossing stamp is an additional guarantee of the authenticity of the print.

Documentation. Most limited edition prints are accompanied with some form of certification, usually consisting of a published statement noting how many copies of the print were produced, the paper type, and other printmaking details.

About Paper

Paper. Because paper made from trees is very acidic, it will yellow in a few years if exposed to light and will eventually decay. Most, if not all, Indian graphics produced before 1977 were printed on acidic paper. If a collector feels such a print is valuable enough, it can be deacidified by a specialist. Brand names of commonly used acidic papers are Mayfair, Teton, Sockeye, Carlyle, Strathmore, and Tweedweave. Today, better quality prints are printed on neutral pH papers, usually made from rags. Common brand names of rag paper are Arches and Rives. Types of paper can often be identified by holding a sheet up to the light and finding the watermark. The brand name will be impressed in the fibres of the paper, usually in one corner of the sheet.

Deckle edge. Some papers, particularly those which are handmade, have thin uneven edges where the paper has thinned out during the manufacturing process. Collectors frequently prefer prints screened on paper with deckle edges, and many recent Northwest Coast Indian prints are on this type of paper.

Care of Prints

Trimming. Fine art prints should never be trimmed for any reason and doing so greatly reduces their value.

Storage. Prints should be stored so that they are in contact with nonacidic matboard or separators. Many museums store prints in drawers to avoid exposure to ultraviolet light.

Framing. As is true with all fine art graphics, a Northwest Coast Indian silk screen print is best protected if the frame does not allow the print to come into contact with the glass and if the matboard backing is made from acid-free ragboard. Unless special protective glass is used, the framed print should be hung away from direct sunlight. Collectors wishing to frame valuable prints should specify "museum quality" framing.

For Further Reading

The literature on the Indian cultures of the Northwest Coast is voluminous. The serious student can find a listing of major articles and monographs relating to Northwest Coast Indians in George Peter Murdock's and Timothy J. O'Leary's *Ethnographic Bibliography of North America* (1975). For those wishing to learn more about the art of the Northwest Coast, the spring 1975 issue of the journal *B.C. Studies* contains a bibliography of Northwest Coast Indian arts and crafts. Below we have suggested a few general sources on Northwest Coast cultures, Northwest Coast art, and silk screen prints.

Anonymous
1977 *Northwest Coast Indian Artists Guild 1977 Graphics Collection.* Ottawa: Canadian Indian Marketing Services.
1978 *Northwest Coast Indian Artists Guild 1978 Graphics Collection.* Ottawa: Canadian Indian Marketing Services.
 These catalogues to the first two collections of silk screen prints produced by members of the recently formed Northwest Coast Indian Artists Guild provide brief biographies of the contributing artists and background material on the subject matter of each print. Designs are illustrated in full color.

1978 *First Annual Collection 'Ksan 1978 Original Graphics.* Vancouver: Children of the Raven Publishing Inc.
 Catalogue to the first collection of silk screen prints issued by the artists of 'Ksan. Prints are shown in full color, with dimensions noted. The text provides an explanation of each design, an introduction to the individual artists, and suggestions for framing prints.

Biegeleisen, J.I.
1963 *The Complete Book of Silk Screen Printing Production.* New York: Dover Publications, Inc.
 An introduction to the technical aspects of the silk screen process.

Boas, Franz
1955 *Primitive Art* (rev. ed.). New York: Dover Publications.
 Chapter 6 of Boas's work is the classic statement on the Northwest Coast art style. Particularly thoroughly treated are the symbolic representation of animal forms and the arrangement of designs on various design fields. Geometric basketry designs are also discussed.

Drucker, Philip
1955 *Indians of the Northwest Coast.* Garden City, New Jersey: The Natural History Press.
 A general and thorough introduction to the cultures of the Northwest Coast. Economy, material culture, art, and ceremonies are among the topics discussed.

Duff, Wilson
1964 *The Indian History of British Columbia.* Anthropology in British Columbia, Memoir No. 5, Victoria.
 This volume deals with the impact of white culture upon native Northwest Coast peoples. Changes over the last 200 years in population, economy, social organization, art, religion, and politics are considered.

1967 *Arts of the Raven: Masterworks by the Northwest Coast Indian.* Vancouver: The
 Vancouver Art Gallery.
 This catalogue of Kwakiutl and Northern Northwest Coast art works, produced
 for Canada's centennial, promotes traditional native art as "fine art." In addition
 to numerous photographs of pieces in the exhibit, there are useful sections on the
 development of Northwest Coast art, the elements of Northwest Coast style and
 the aesthetics of the art.
1975 *Images: Stone, B.C.* Saanichton, B.C.: Hancock House Publishers Ltd.
 This catalogue of prehistoric Northwest Coast art illustrates spindle whorls,
 mauls, animal mortars, human figure bowls, and many other pieces. Readers may
 disagree with the author's psychosexual interpretation of the art but will find the
 fine photo reproductions of the lithic works and the catalogue information use-
 ful.

Holm, Bill
1965 *Northwest Coast Indian Art: An Analysis of Form.* Seattle: University of Wash-
 ington Press.
 Holm's now-classic analysis of the Northern Northwest Coast art style is must
 reading for serious students of the art. The formline and related elements and the
 rules for their application are the focus of this book. Virtually all the more recent
 studies of Northwest Coast art have drawn upon this pioneering work.

Kitanmax School of Northwest Coast Indian Art
1977 *We-gyet Wanders On: Legends of the Northwest.* Saanichton, B.C.: Hancock
 House Publishers Ltd.
 Mythical adventures of the Gitksan creator/trickster We-gyet (Raven) are told by
 'Ksan elders and illustrated with serigraph designs by Ken Mowatt and Vernon
 Stephens.

Macnair, Peter L., Alan L. Hoover, and Kevin Neary
1980 *The Legacy,* Victoria B.C.: British Columbia Provincial Museum.
 Catalog of an exhibit which "includes the best of contemporary Northwest Coast
 art . . . (and) also the finest traditional art from the collections of the British
 Columbia Provincial Museum." The reader is thus afforded the opportunity to
 visually compare the new and the old.

Hawthorne, Audrey
1979 *Kwakiutl Art.* Seattle: University of Washington Press.
 An introduction to the craft and technology of Northwest Coast Indian art.

Stewart, Hilary
1979a *Robert Davidson: Haida Printmaker.* Seattle: University of Washington Press.
 An annotated presentation of all the silk screen designs produced by this prolific
 and innovative Haida artist through 1978.
1979b *Looking at Indian Art of the Northwest Coast.* North Vancouver, B.C.: Douglas &
 McIntyre Ltd.
 The author refers to silk screen prints in discussing the key features of Northwest
 Coast art. The formline and formline elements are treated in great detail and
 amply illustrated. Numerous animal forms depicted in the art are shown in silk
 screen designs. The book includes a brief discussion of Tlingit, Haida, 'Ksan,
 Kwakiutl, Westcoast, and Coast Salish art styles.

Zigrosser, Carl, and Christa M. Gaehde
1965 *A Guide to the Collecting and Care of Original Prints.* New York: Crown Publica-
 tions.
 A discussion of fine art prints and how to care for them.